T0061075

BOTANICUM

SPECIAL EDITION COLORING BOOK

ILLUSTRATED BY MARIA TROLLE

GIBBS SMITH
TO ENRICH AND INSPIRE HUMANKIND

To my Family

24 23 11 10 9

Botanicum
Illustrations © 2020 Maria Trolle.
www.mariatrolle.se
Instagram: @maria_trolle

Swedish edition copyright © 2019 Pagina Förlags AB, Sweden.
All rights reserved.

Gibbs Smith
P.O. Box 667
Layton, Utah 84041

1.800.835.4993 orders
www.gibbs-smith.com

ISBN: 978-1-4236-5401-8

THIS BOOK
BELONGS TO:

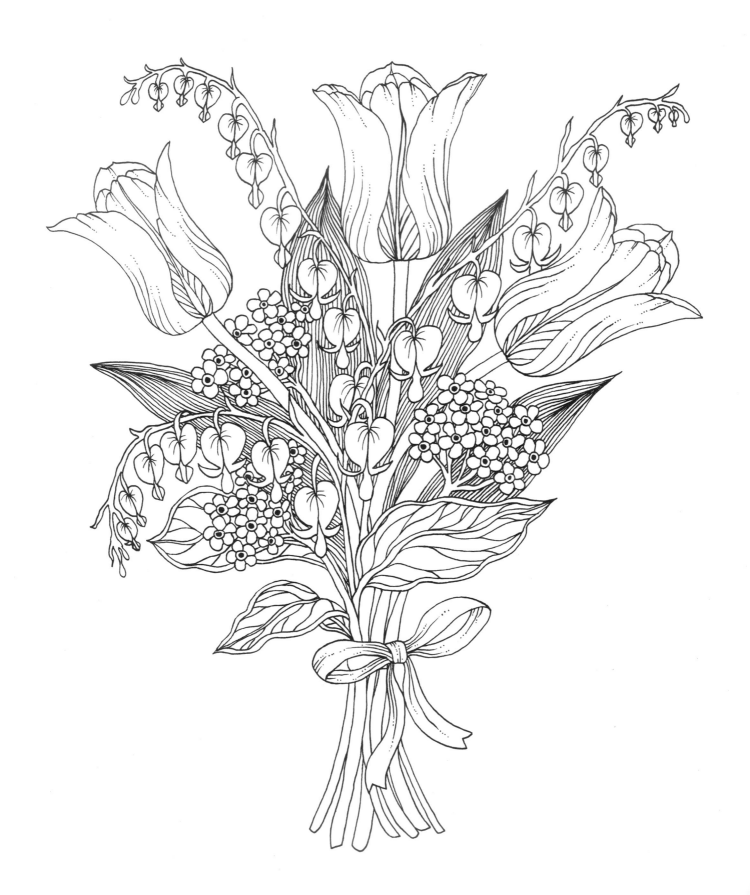

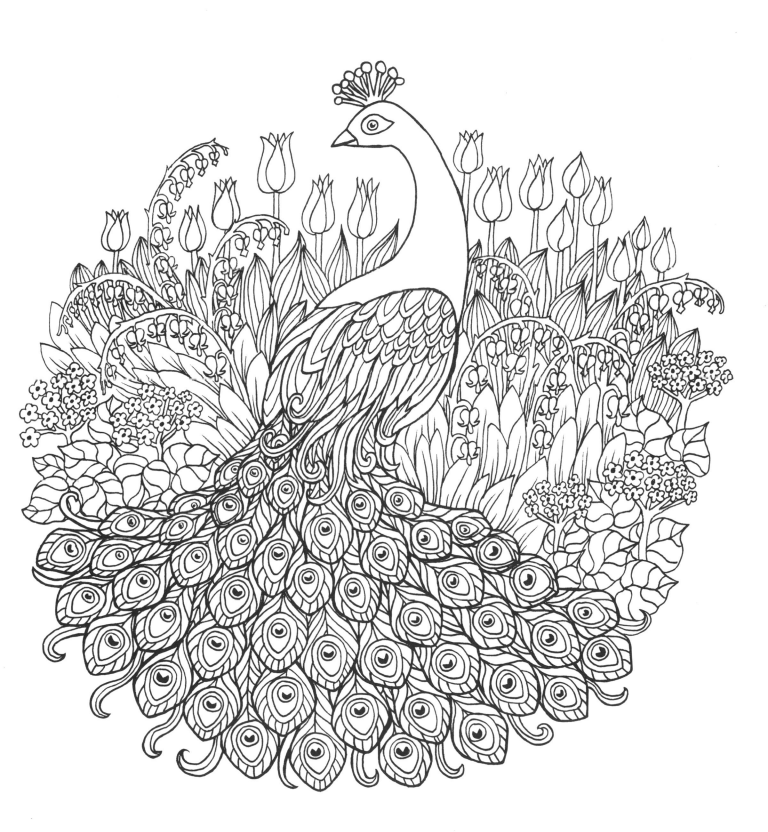

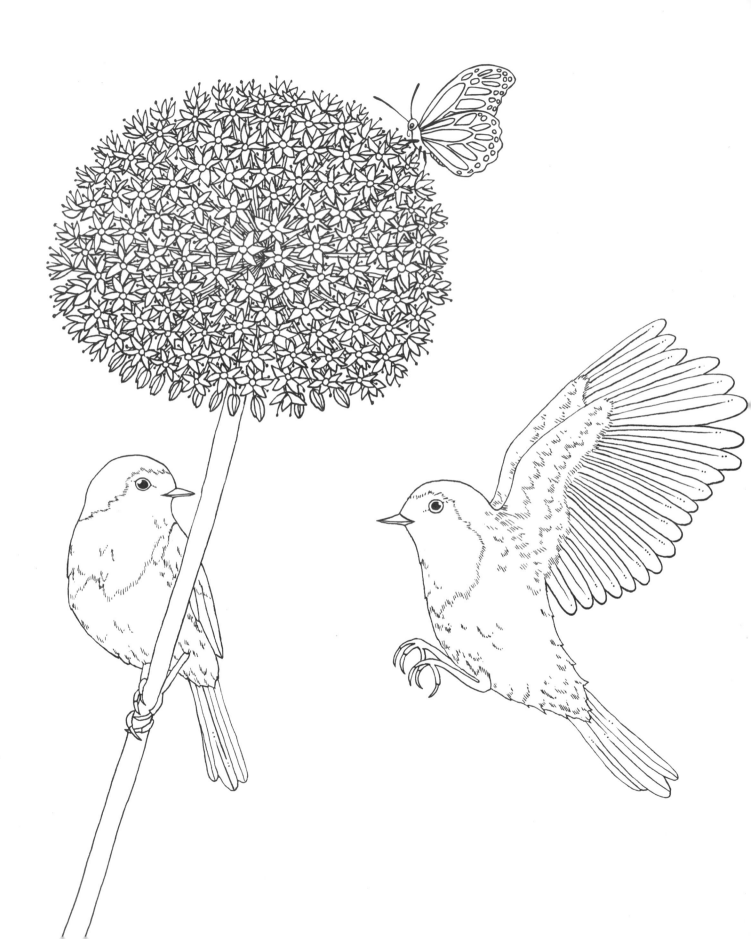

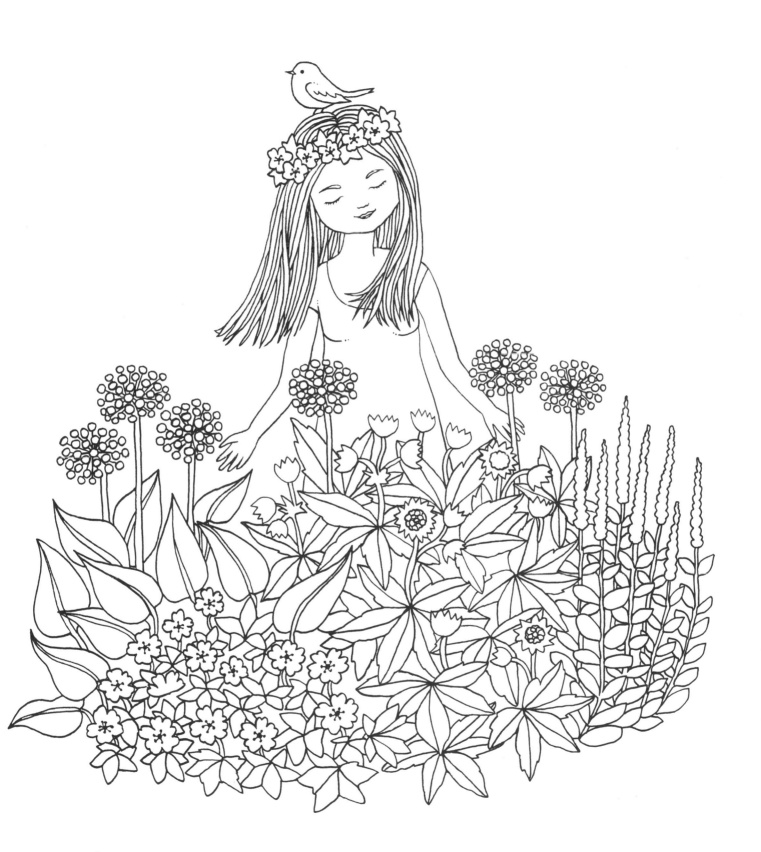

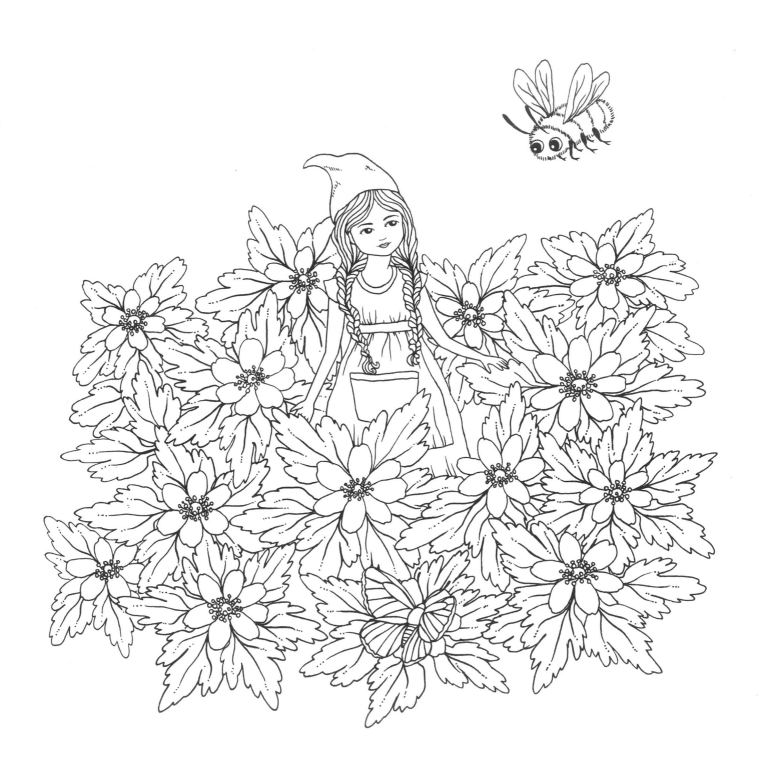

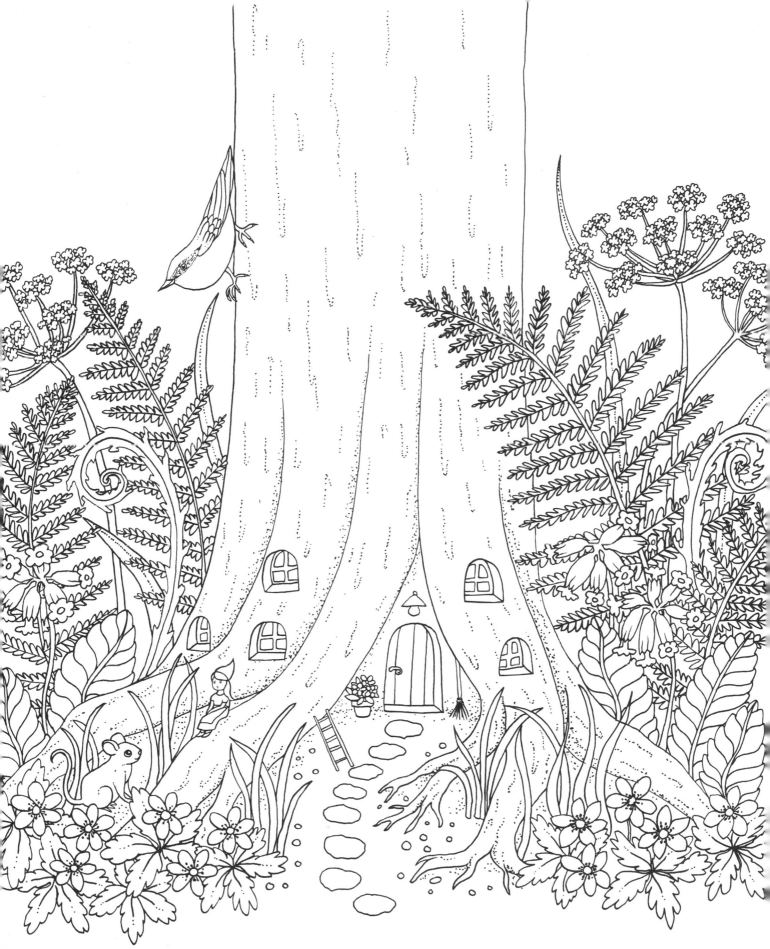

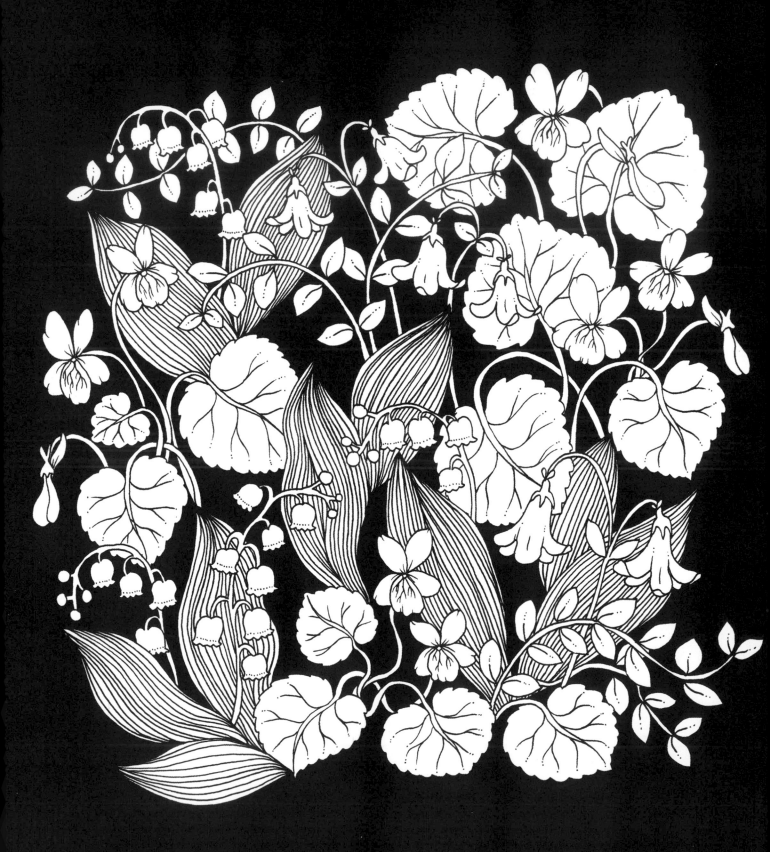

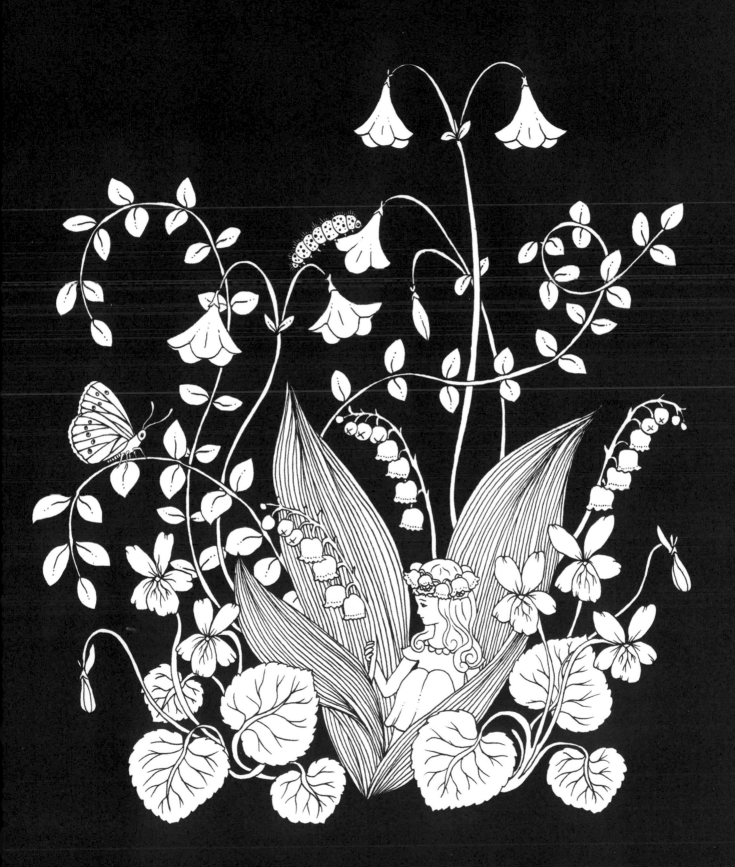

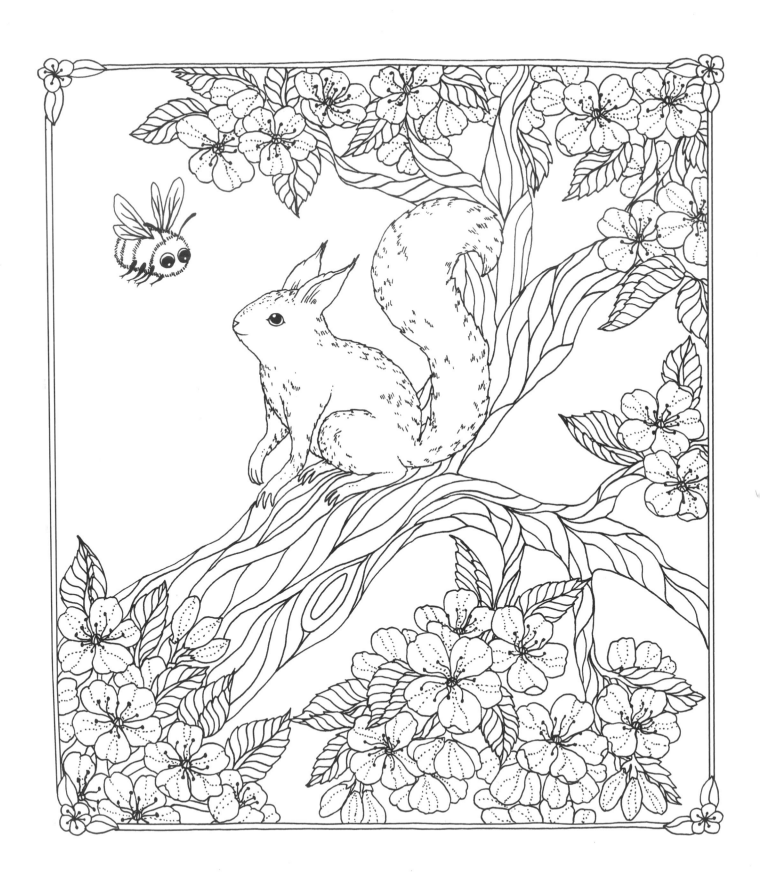

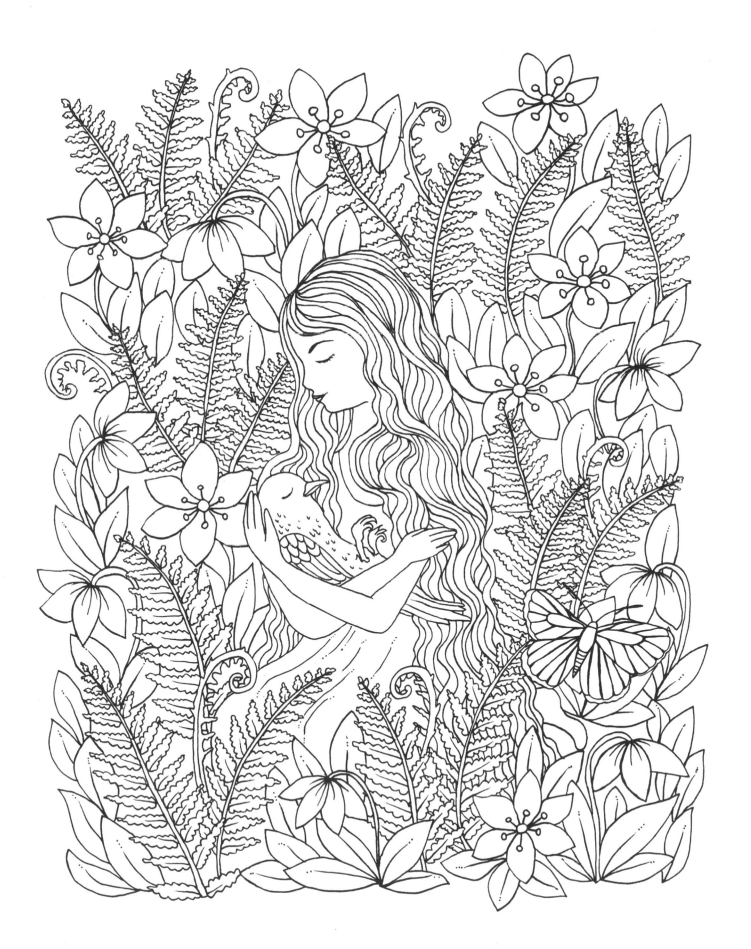

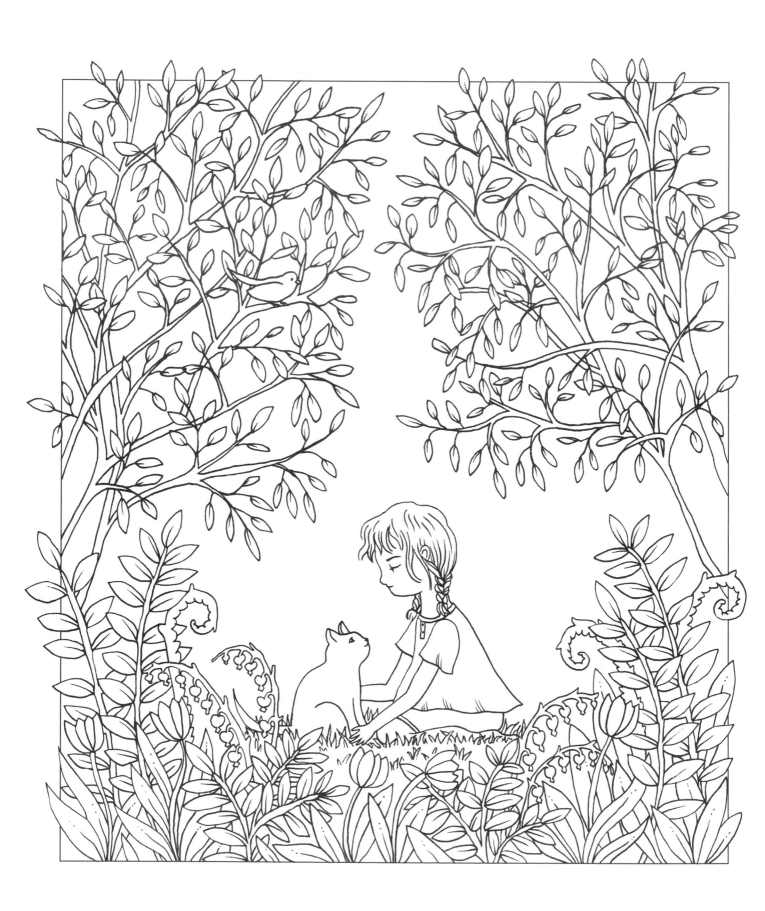

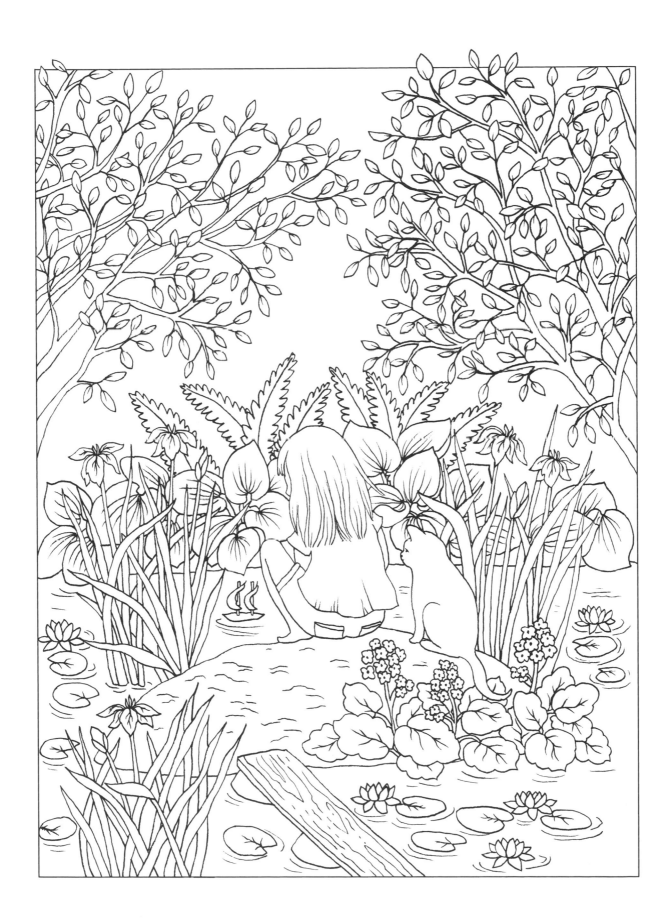

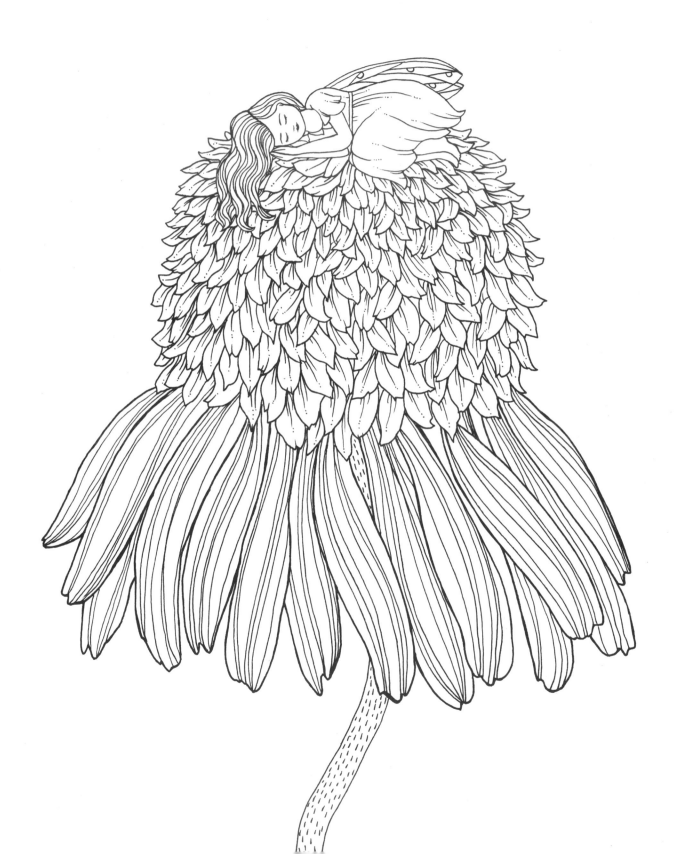

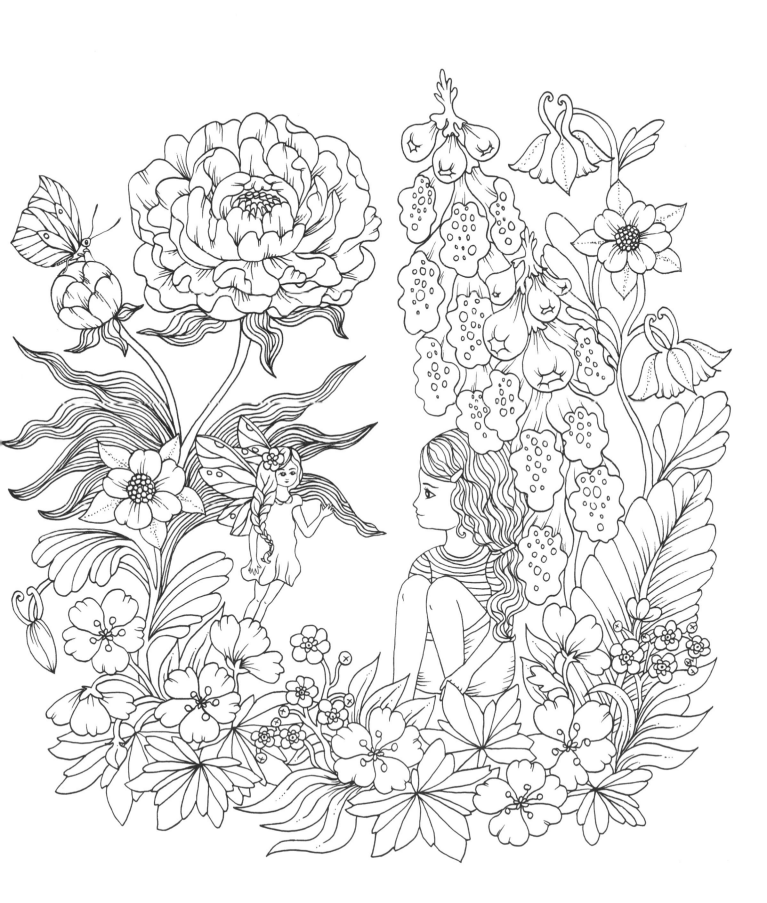

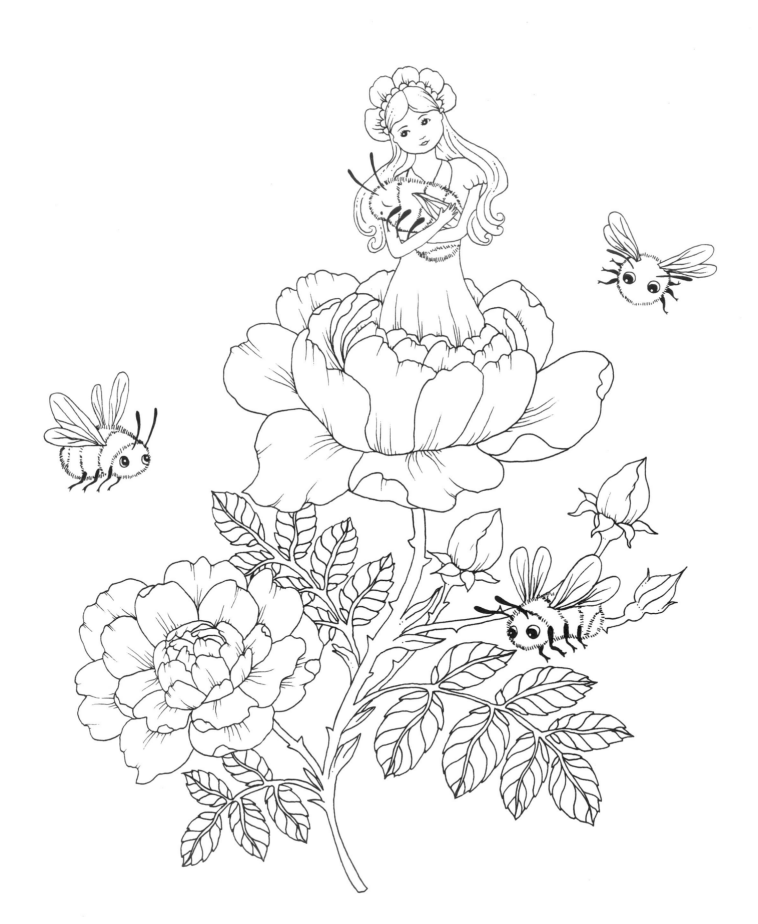

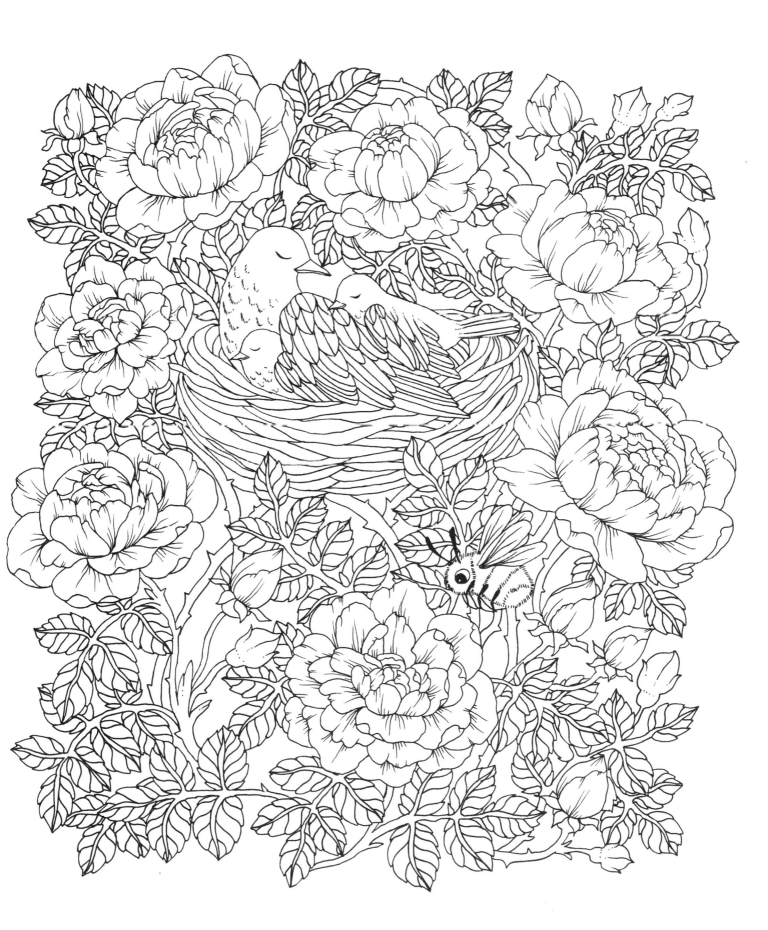

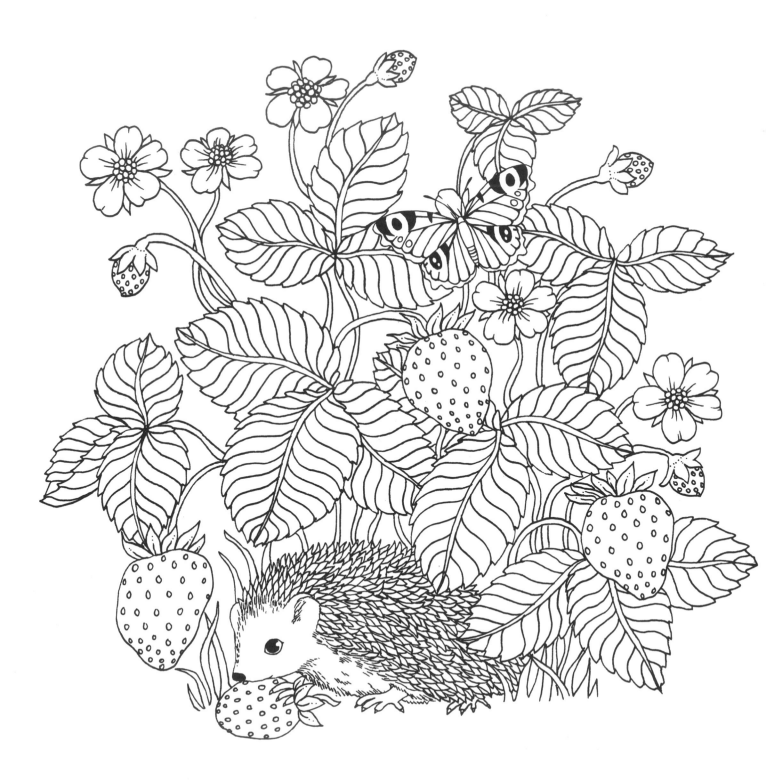

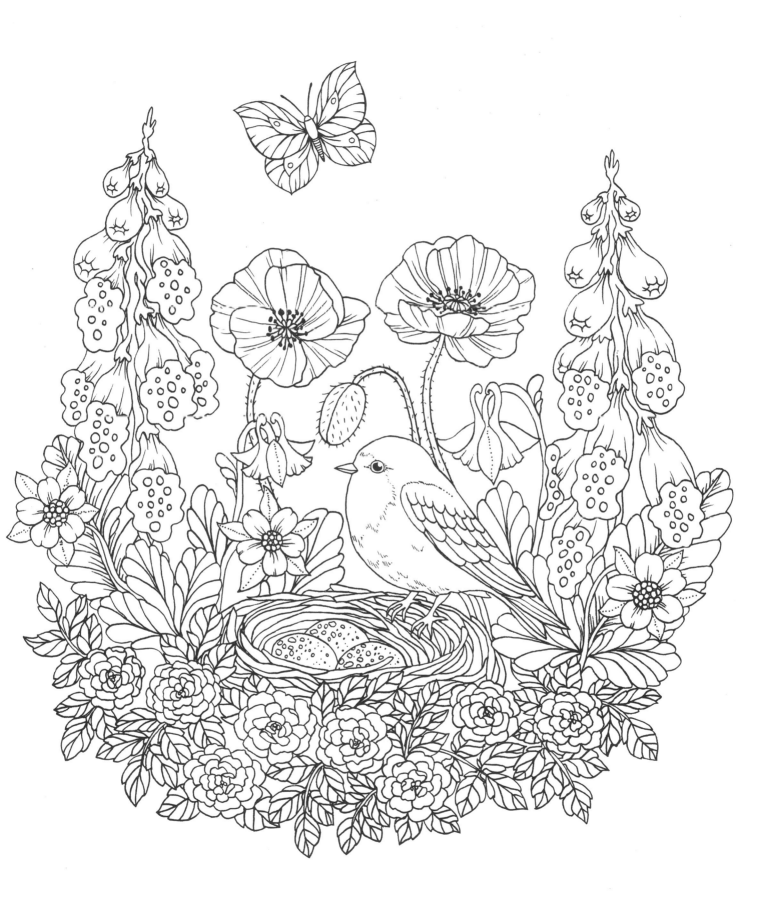

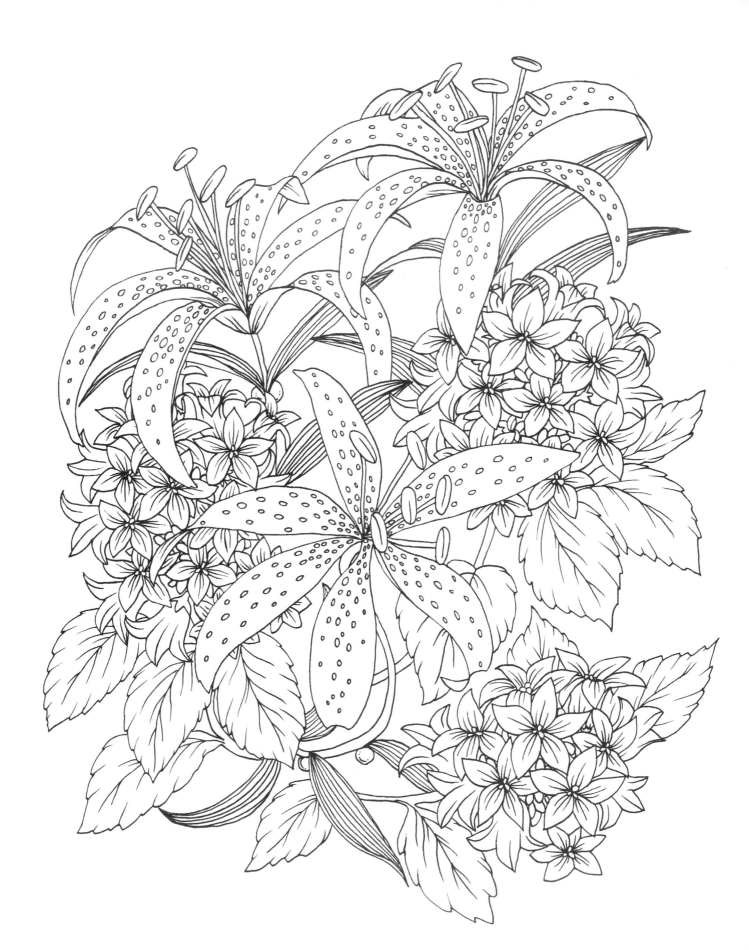

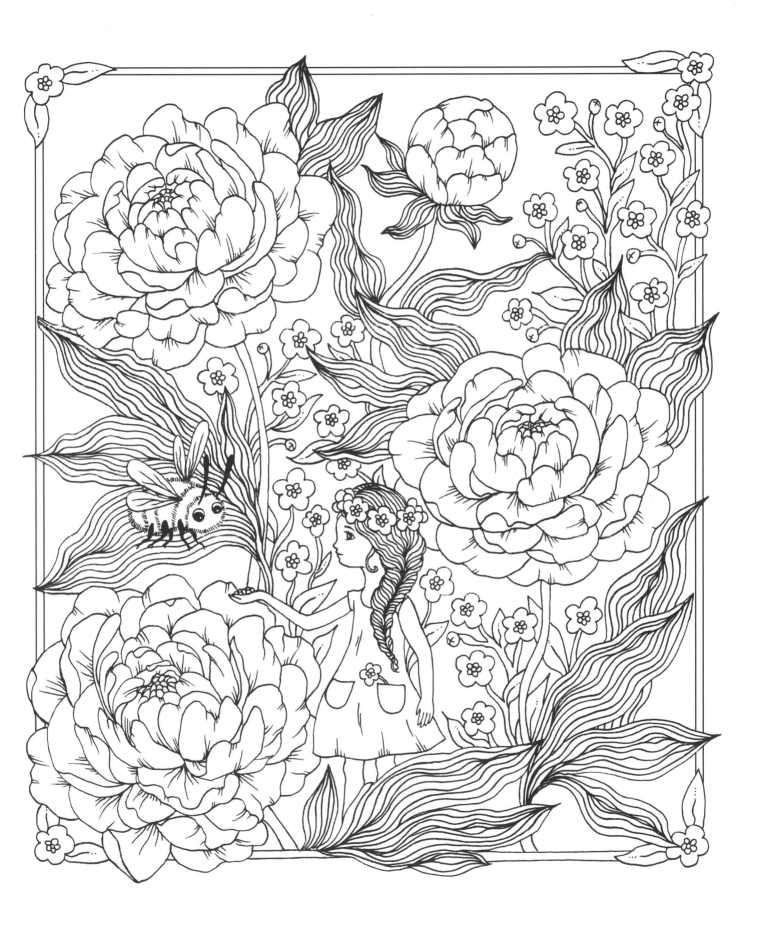

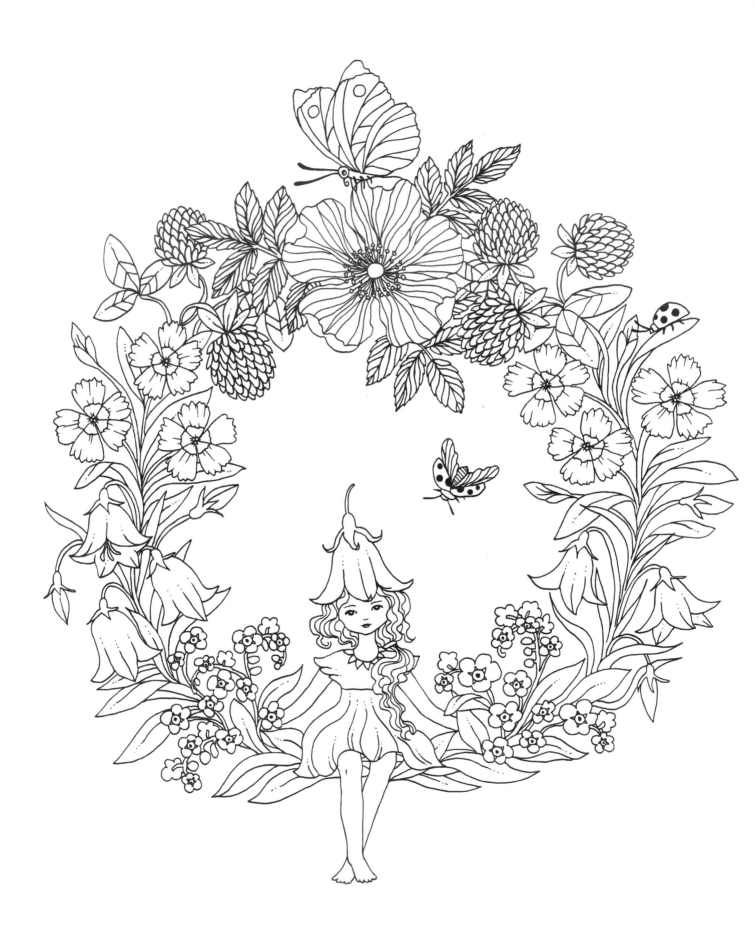

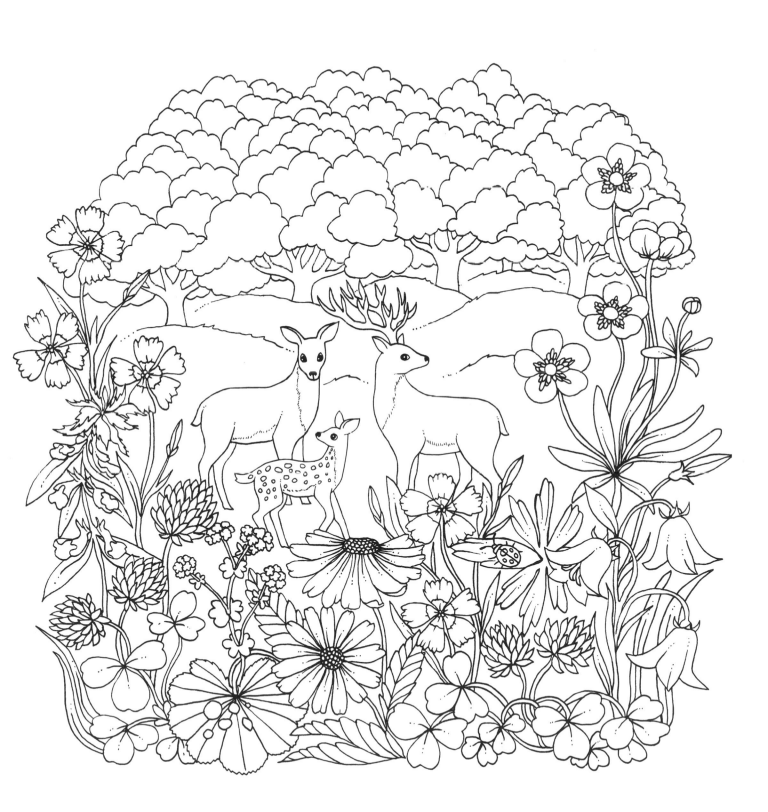

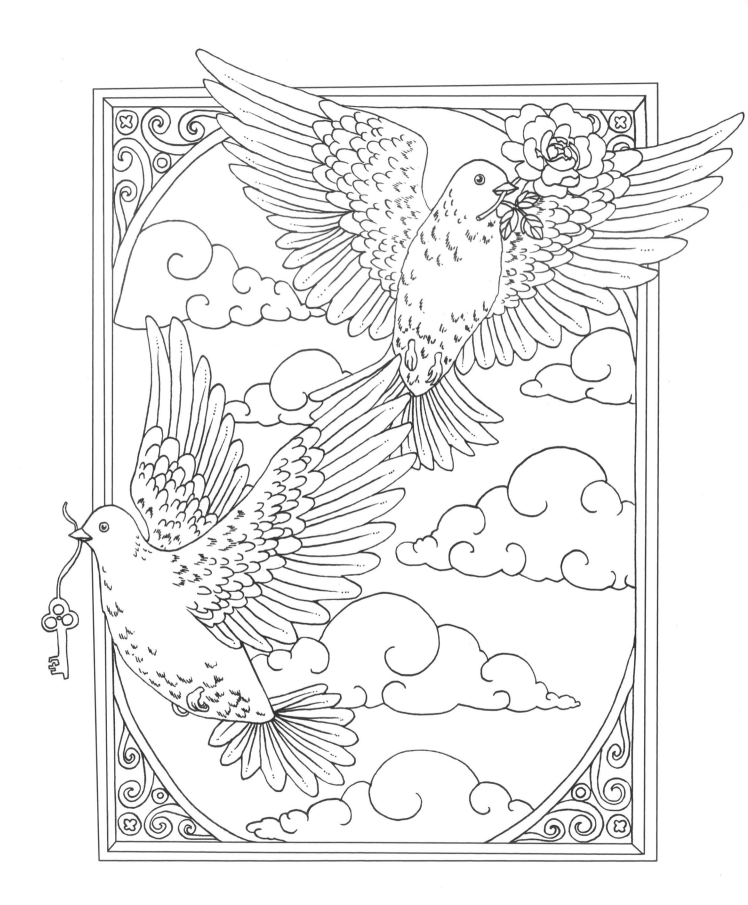

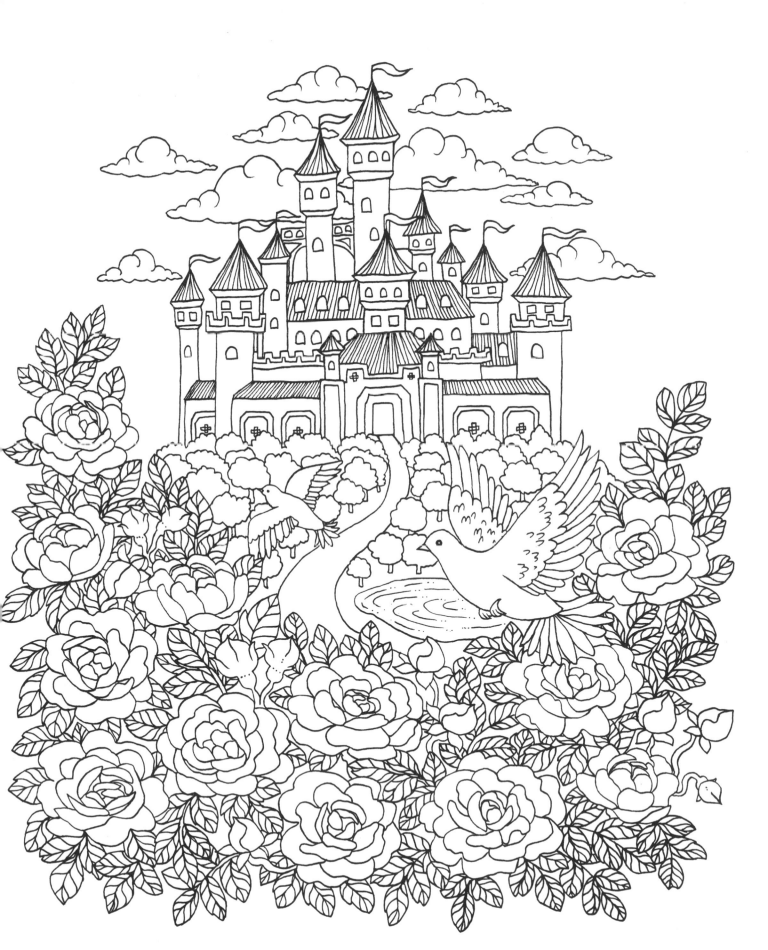

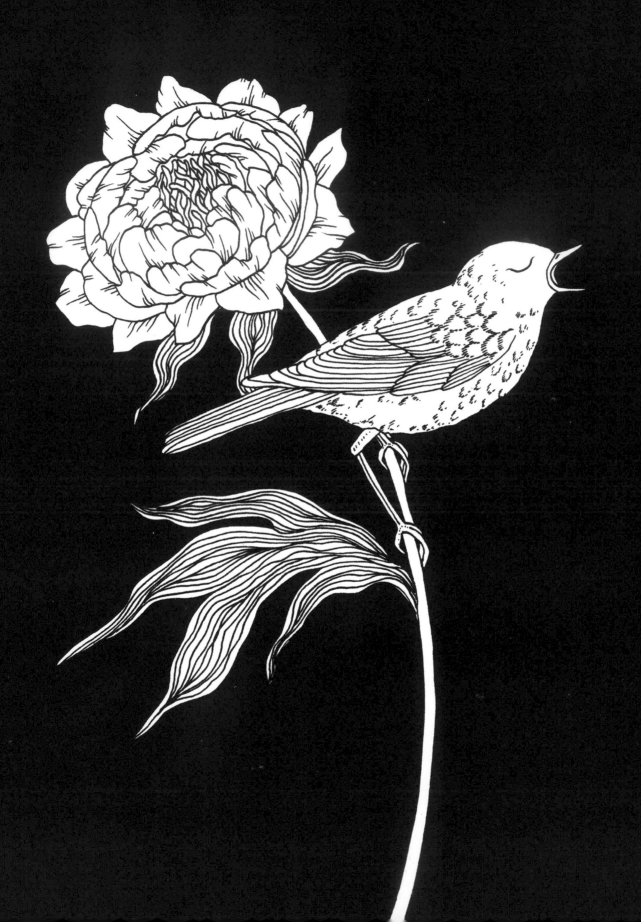

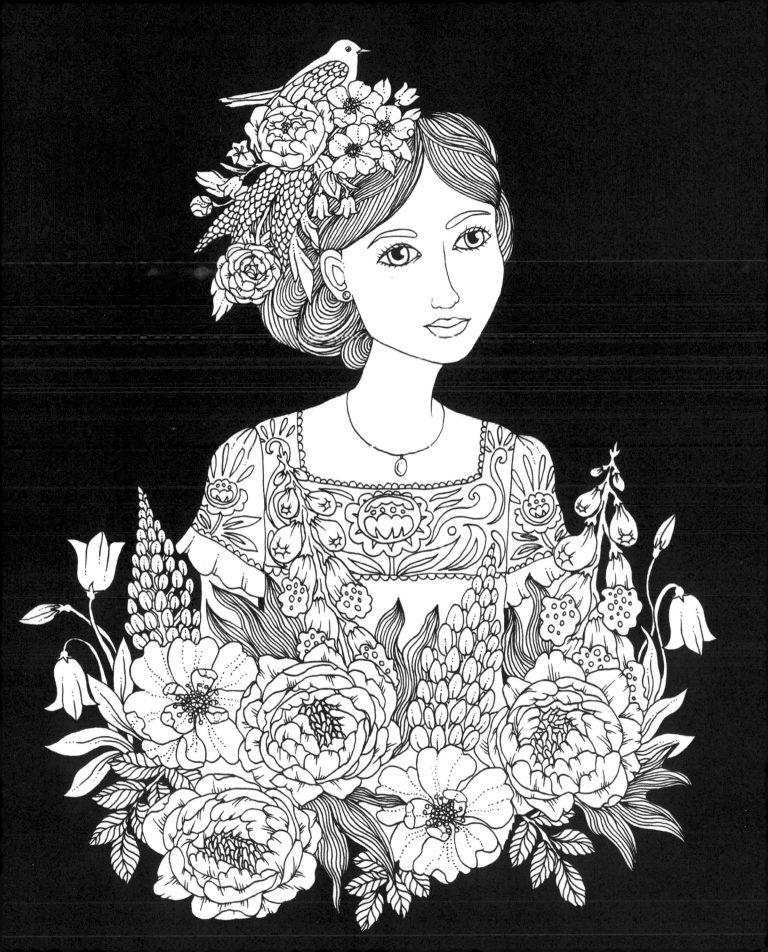

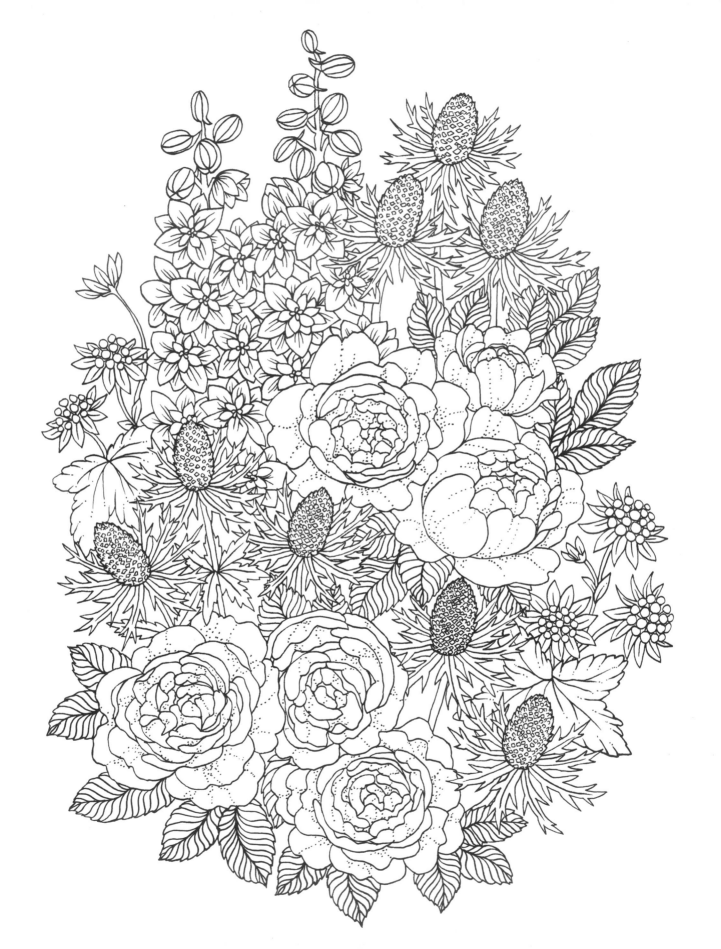

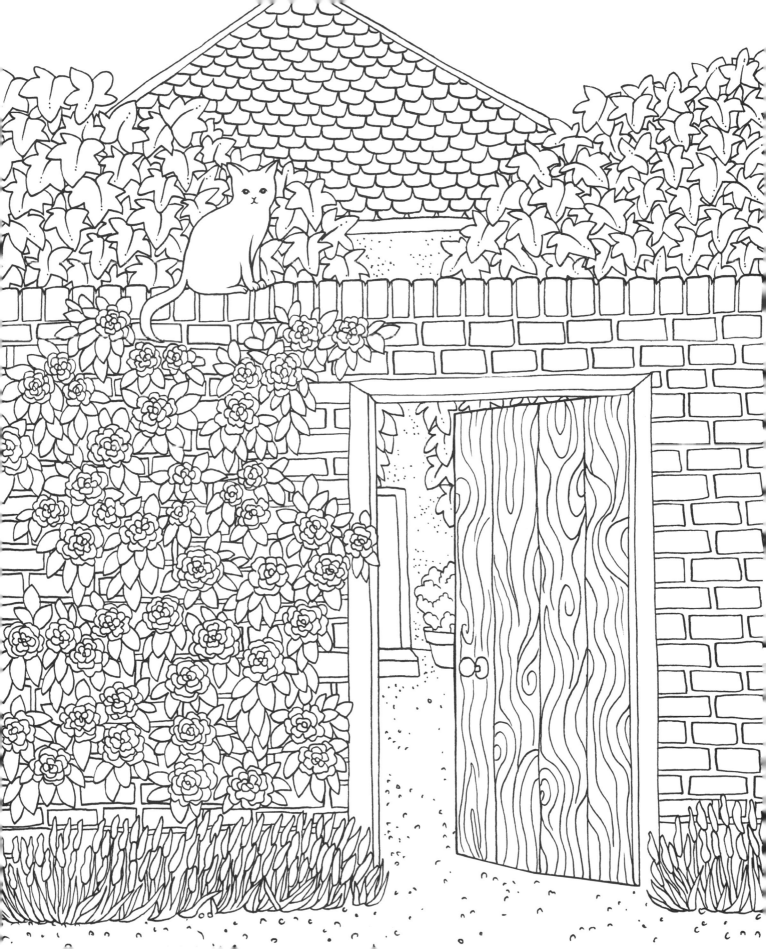

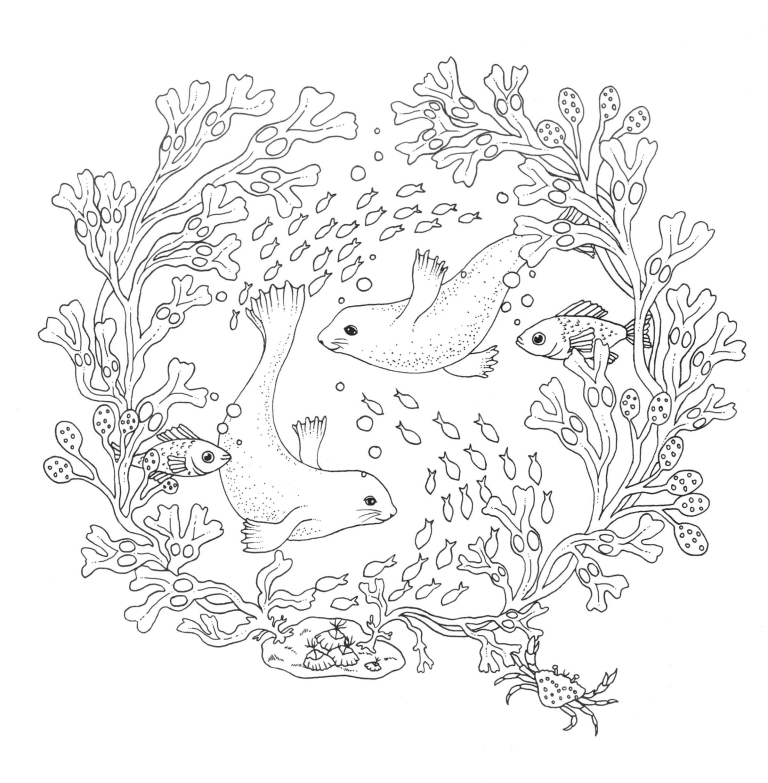

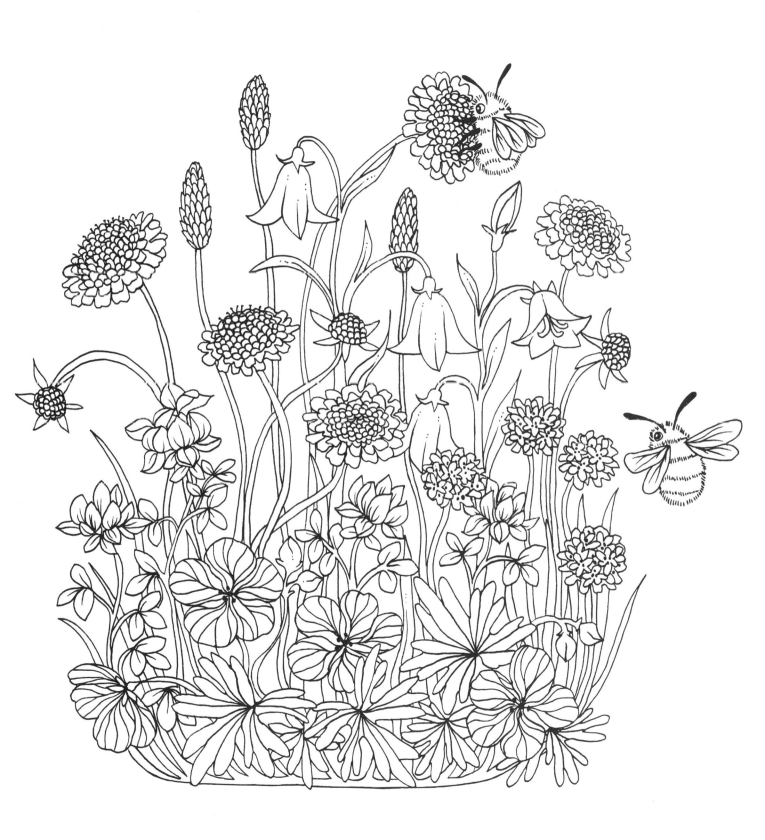

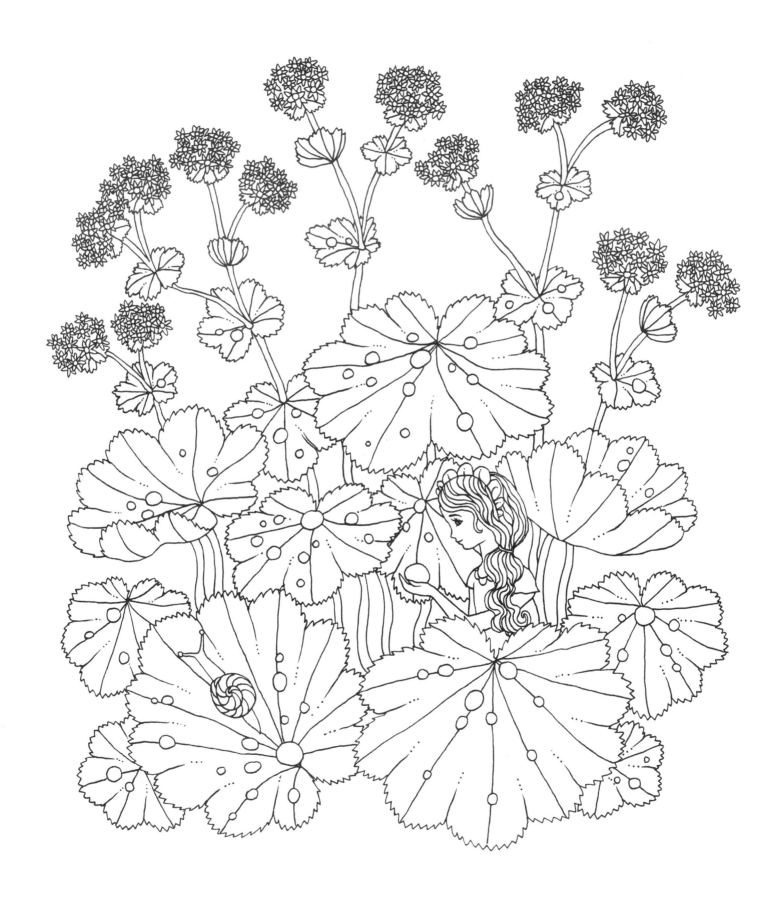

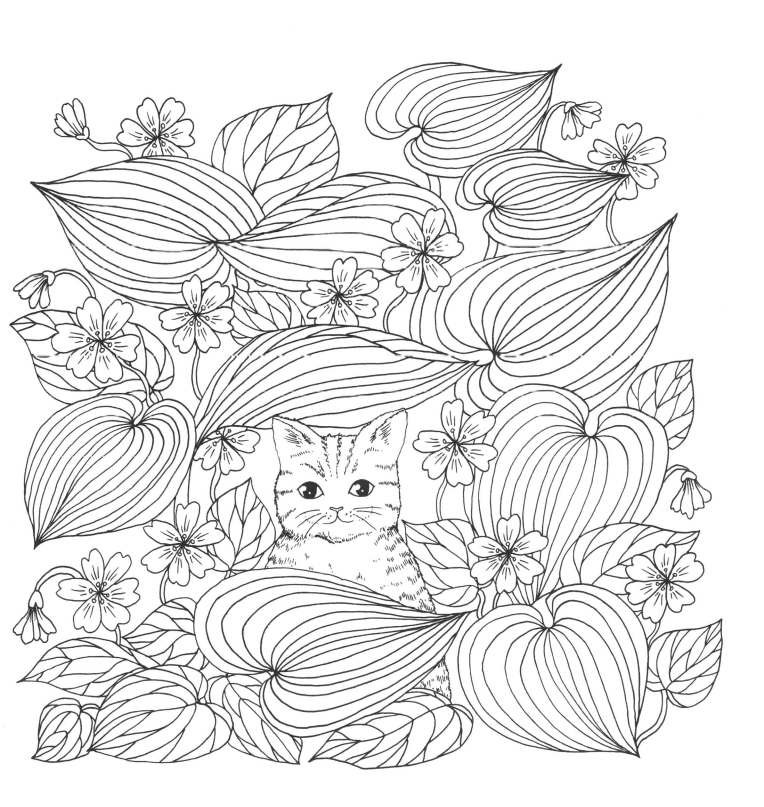

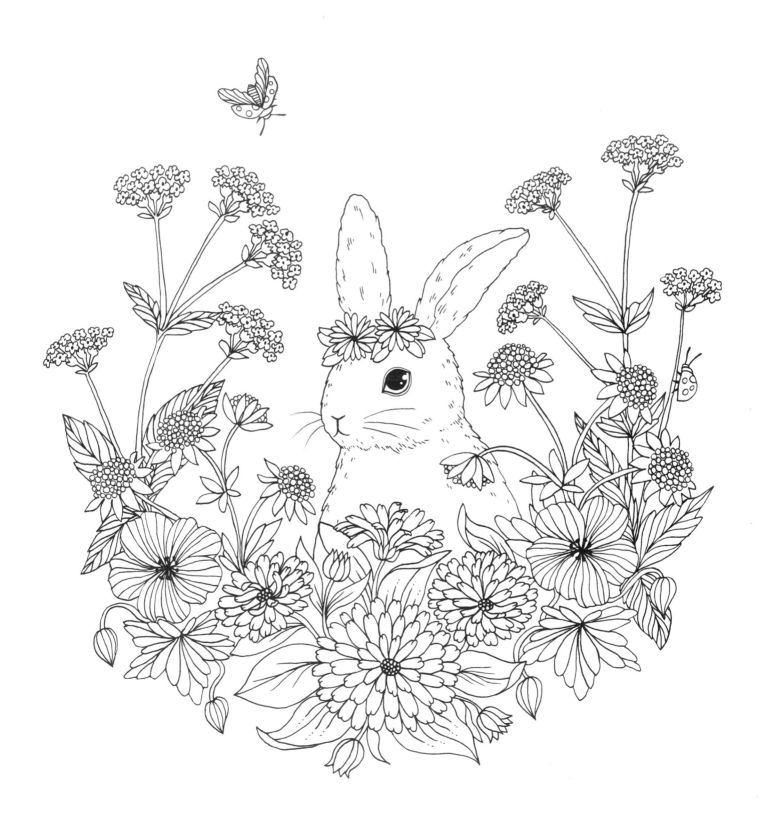

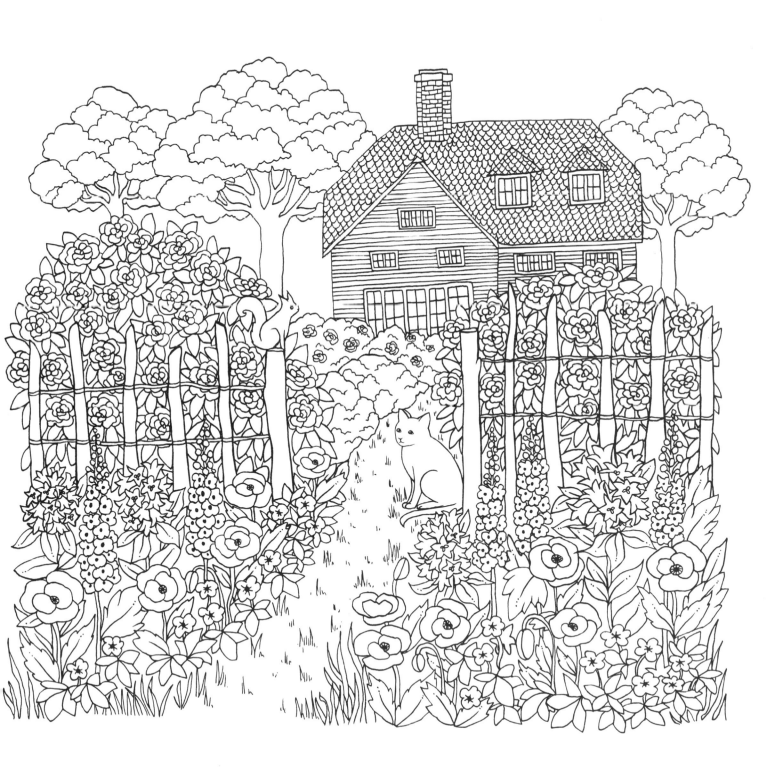

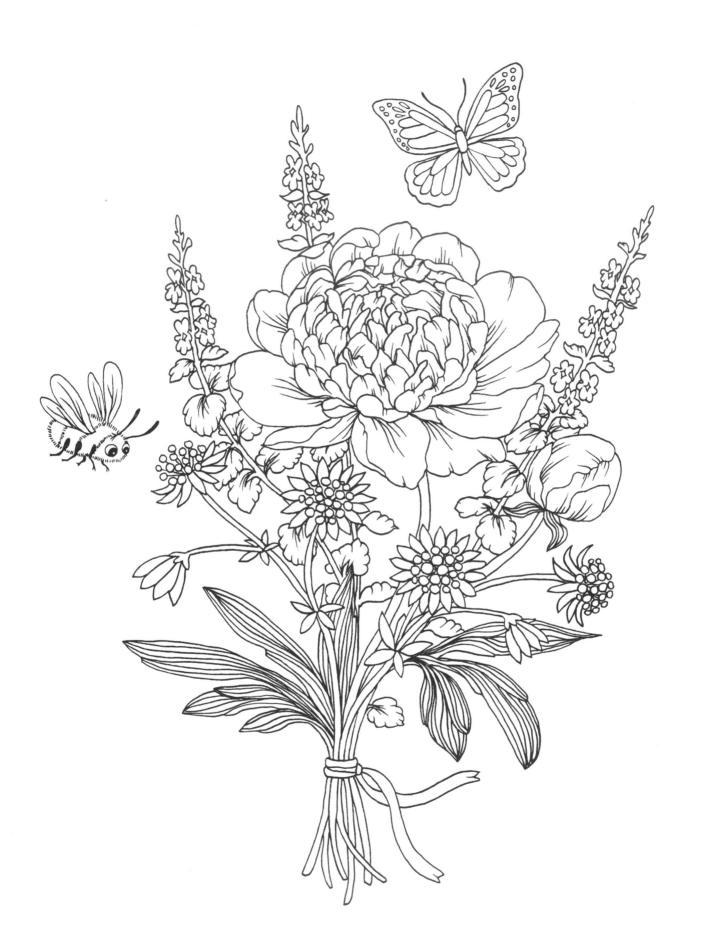

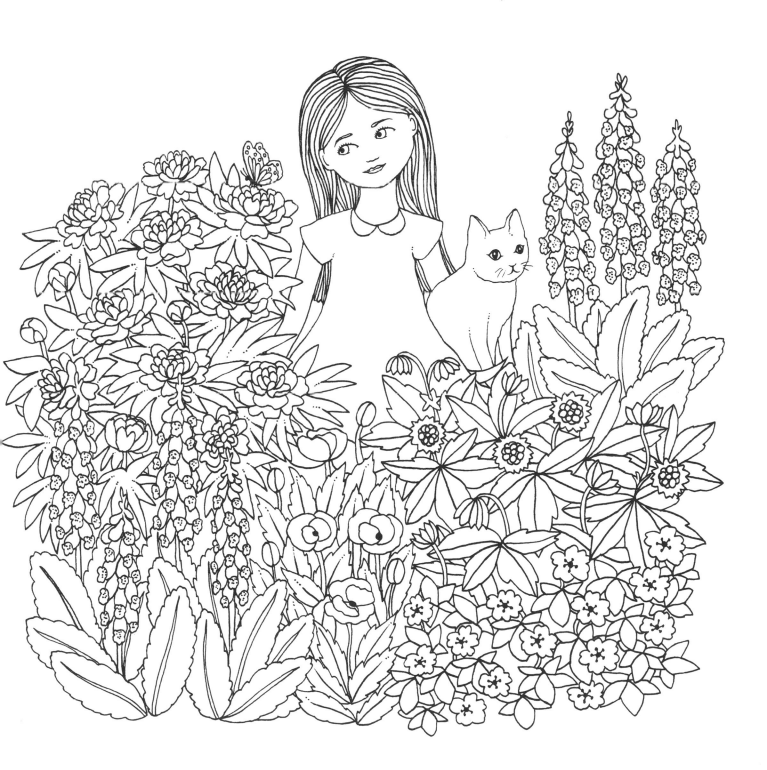

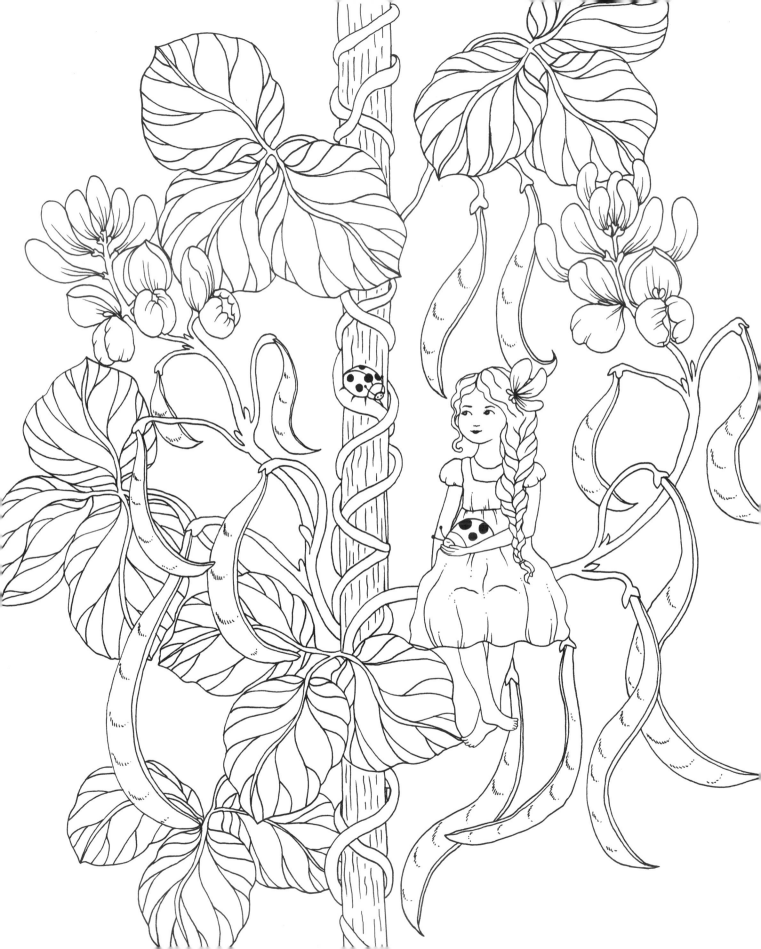

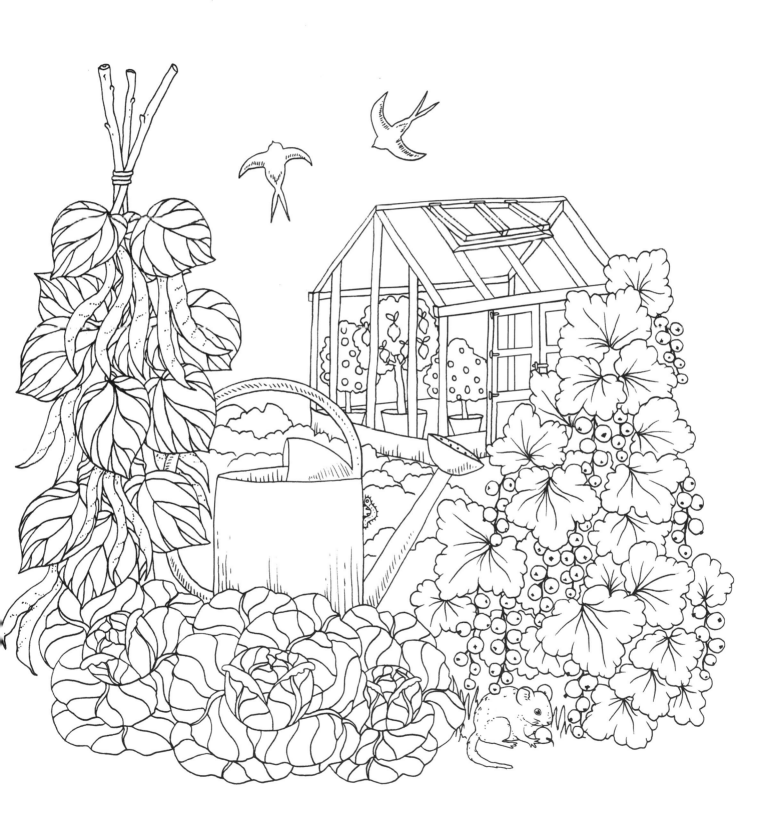

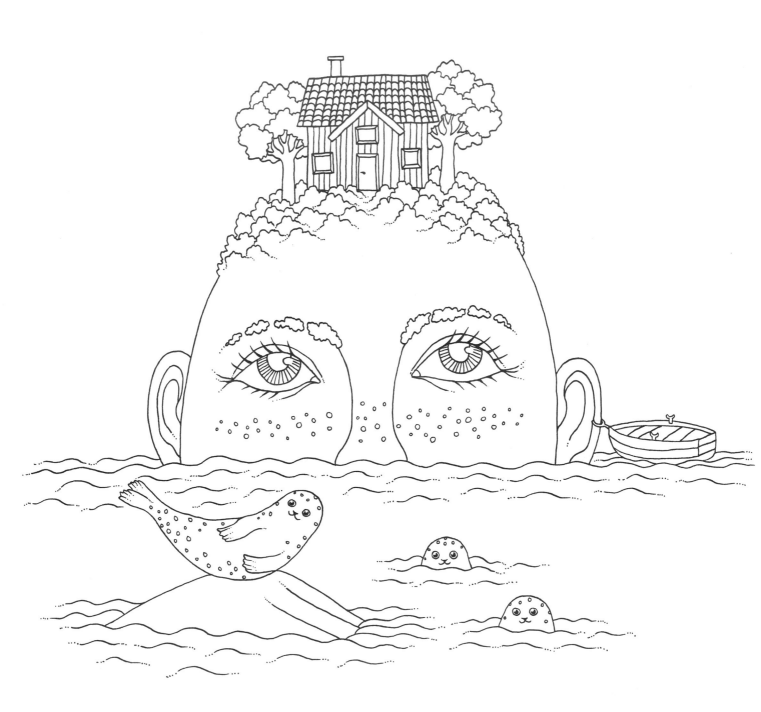

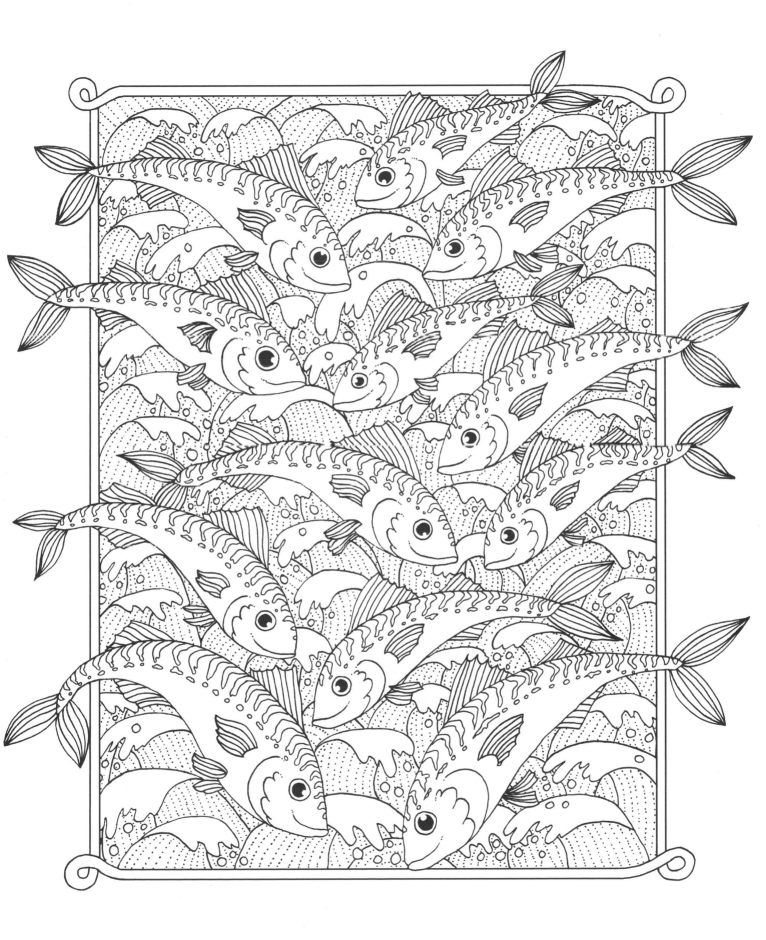

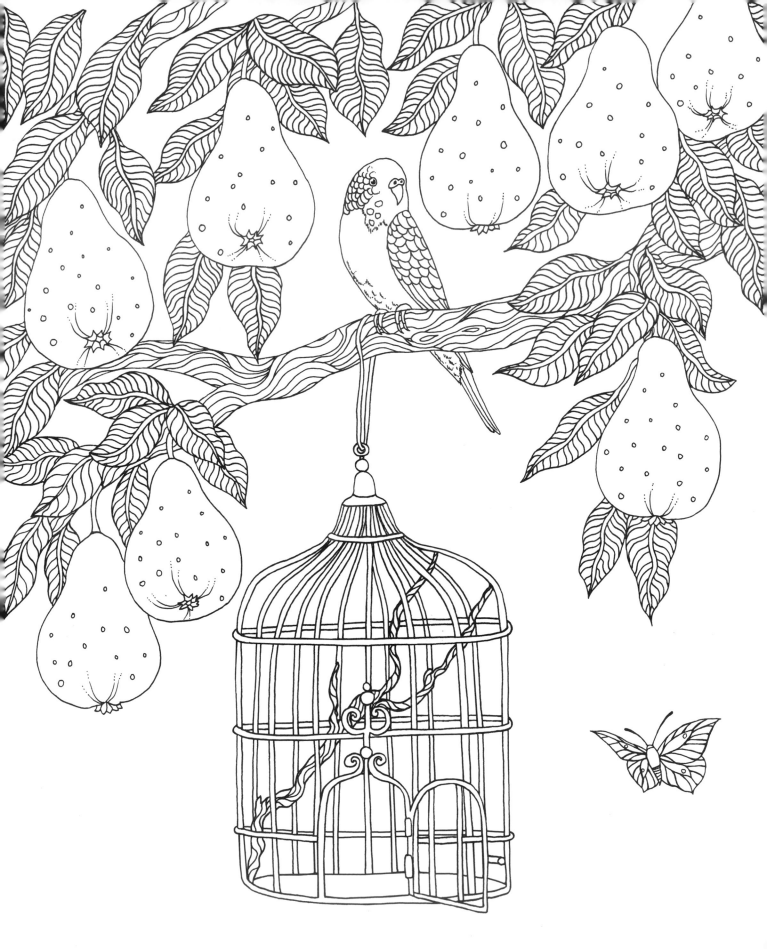

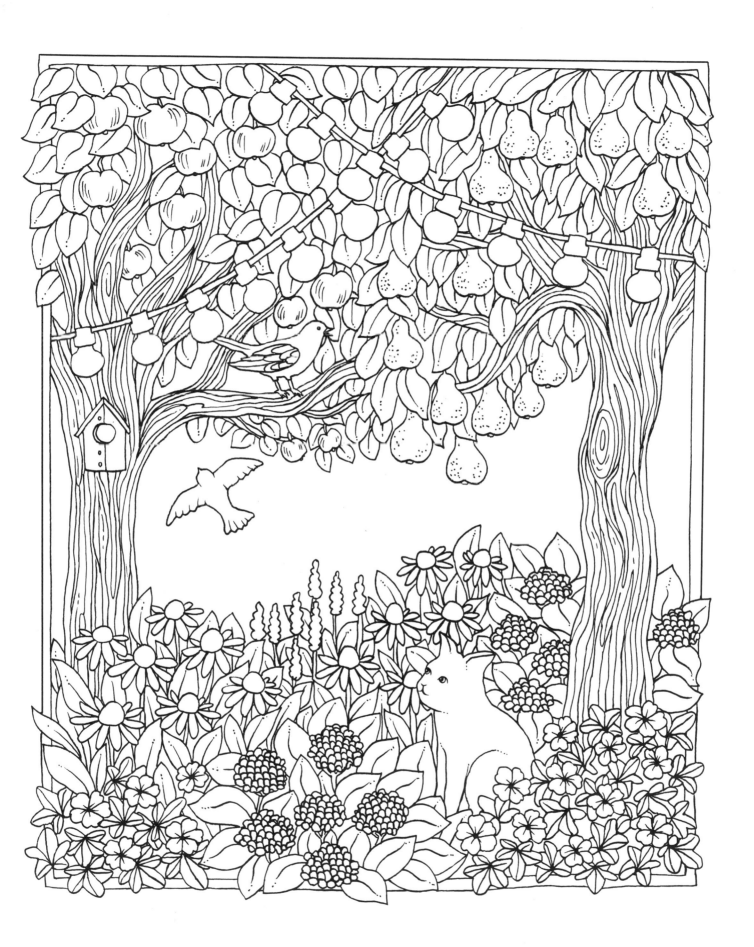

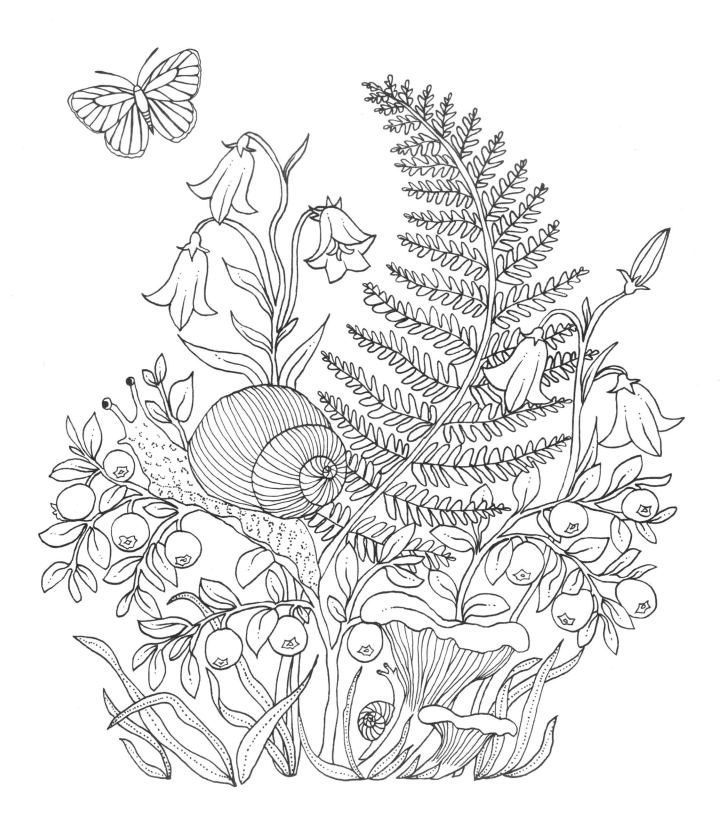

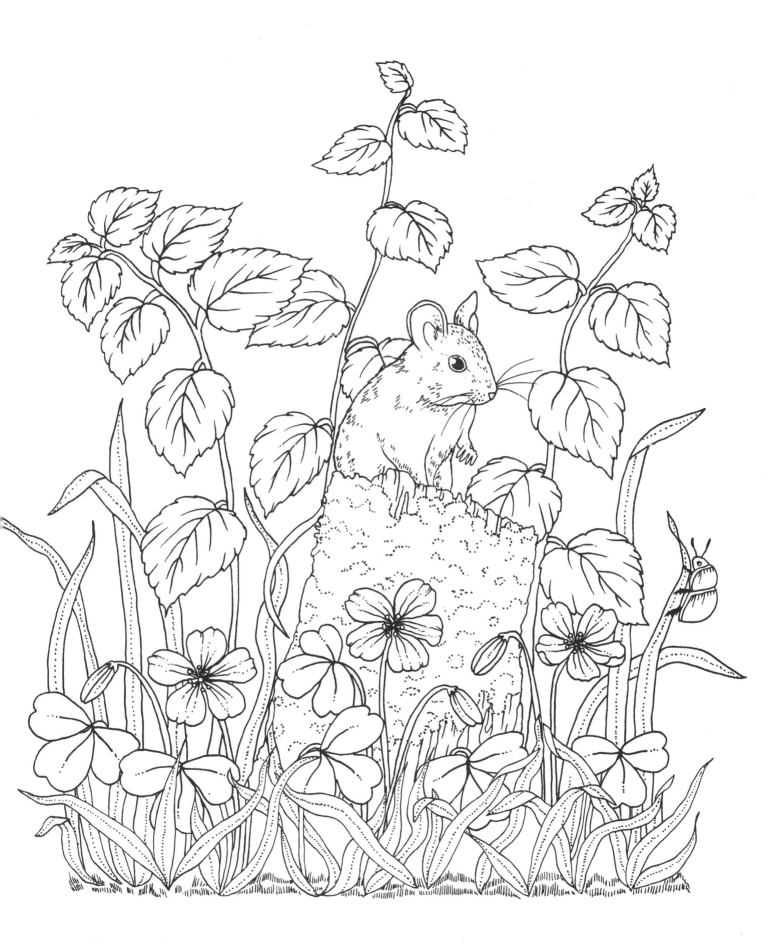

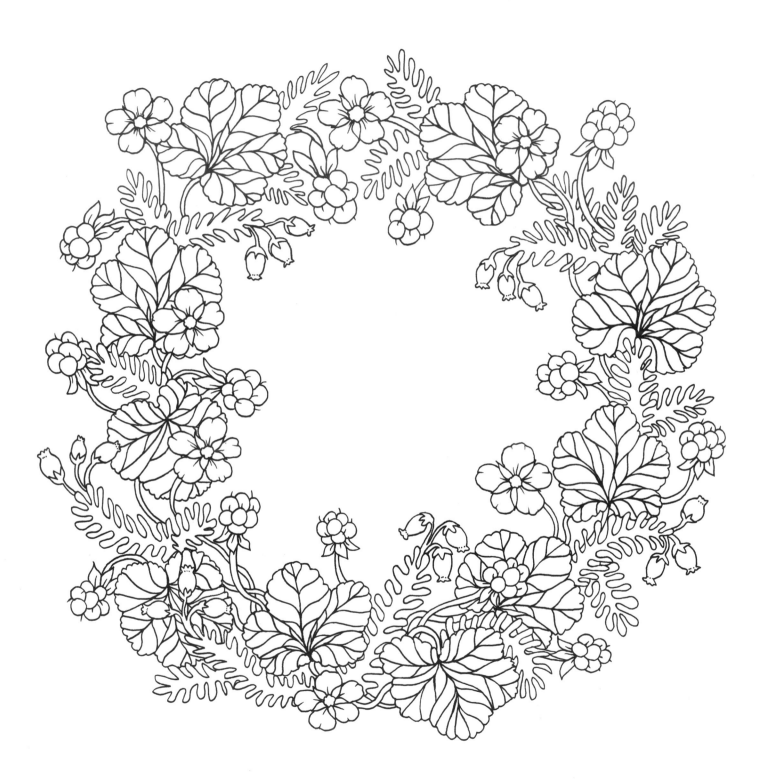

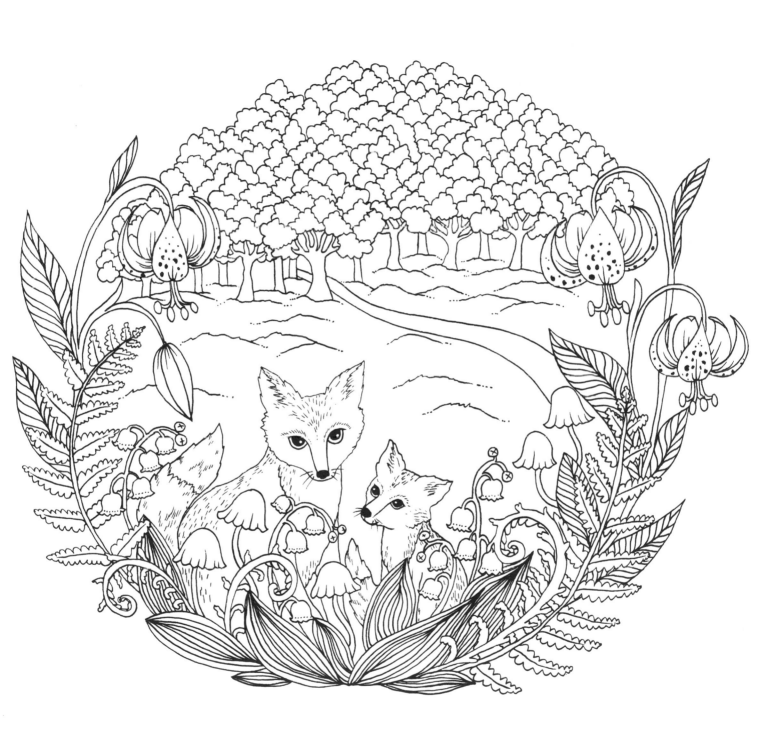

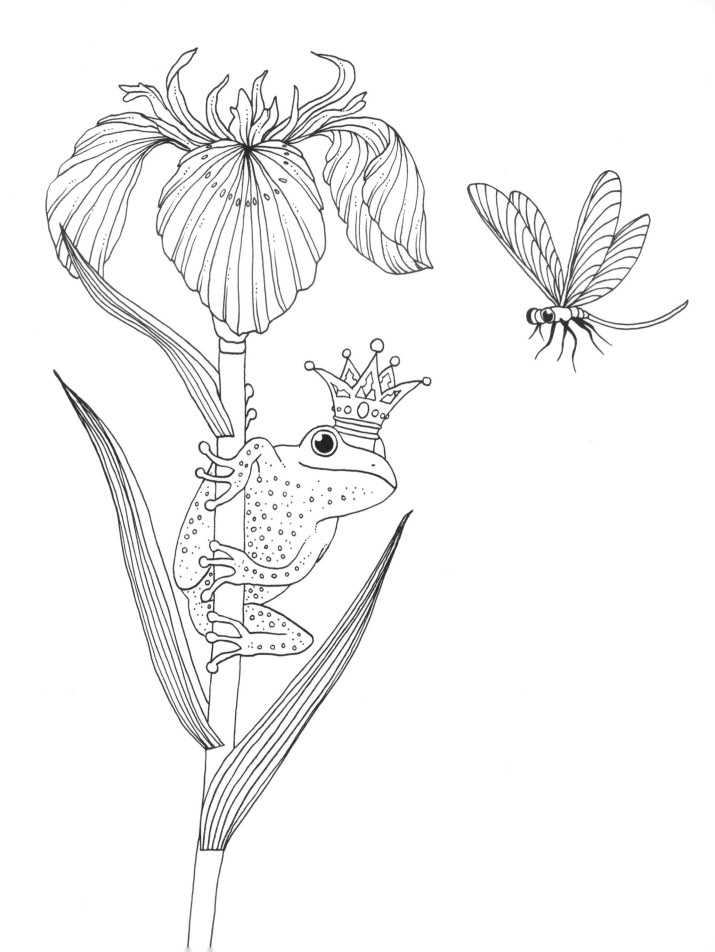

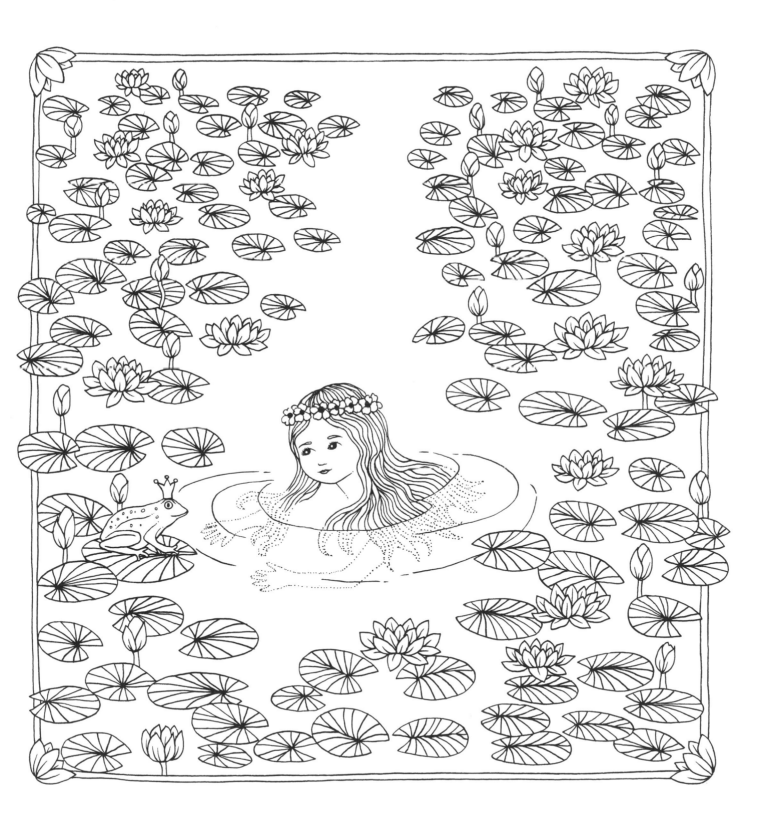

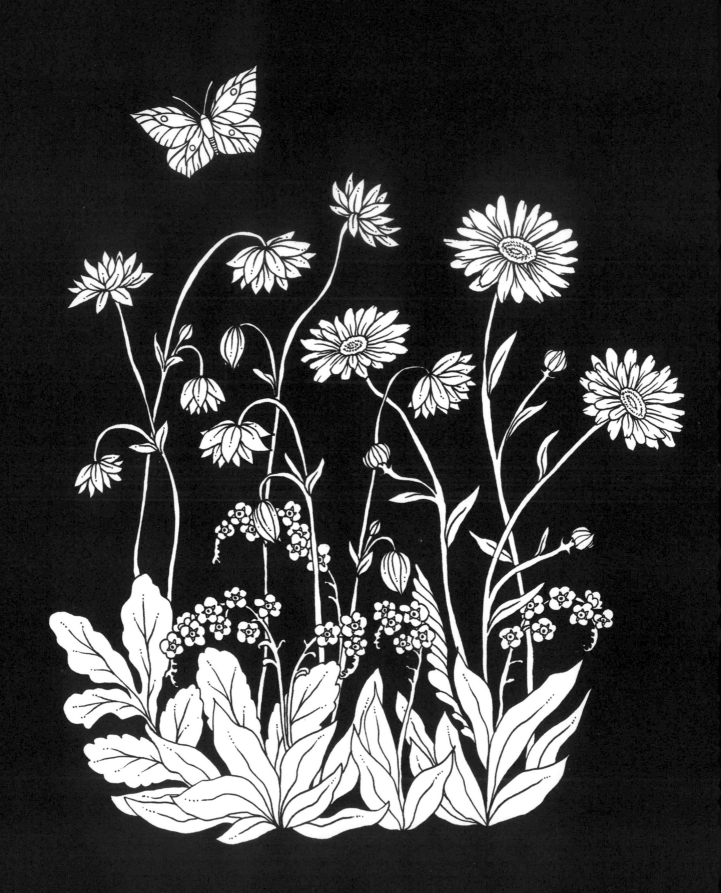

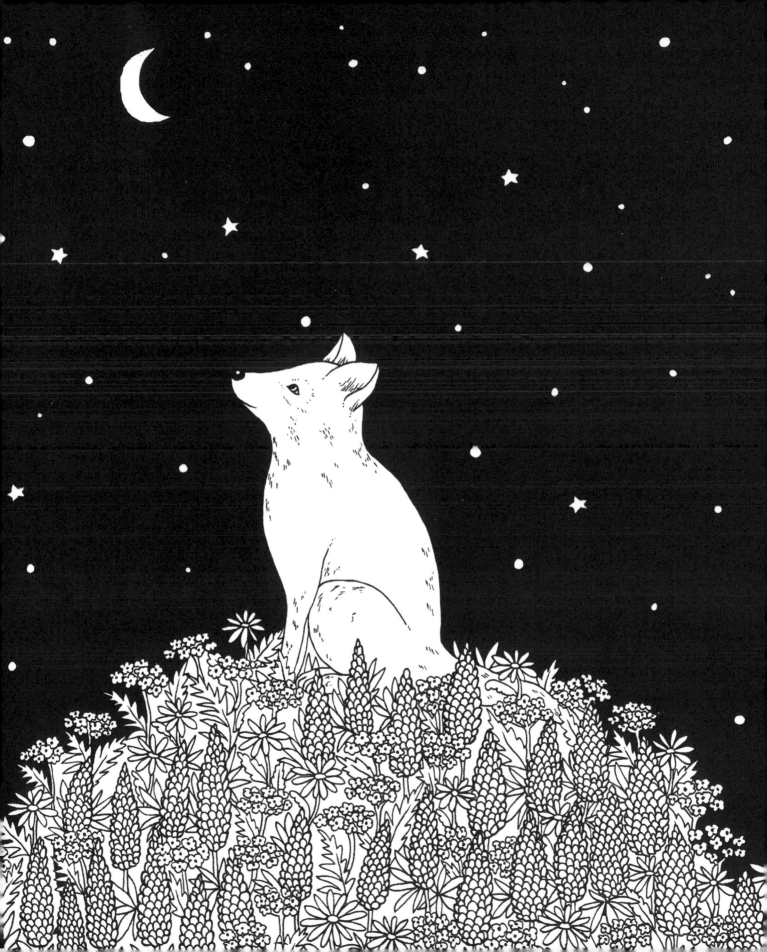

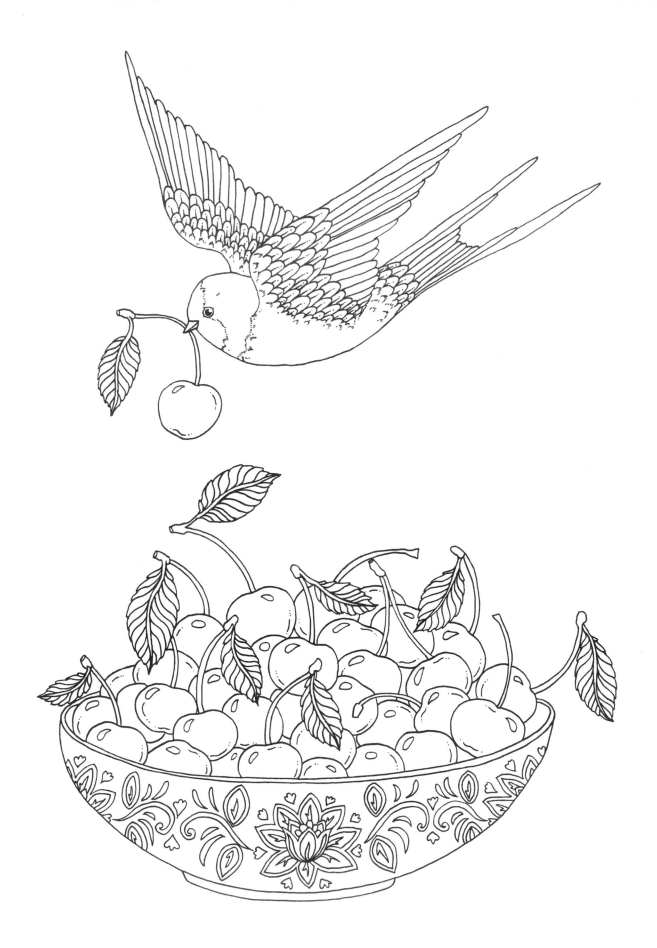

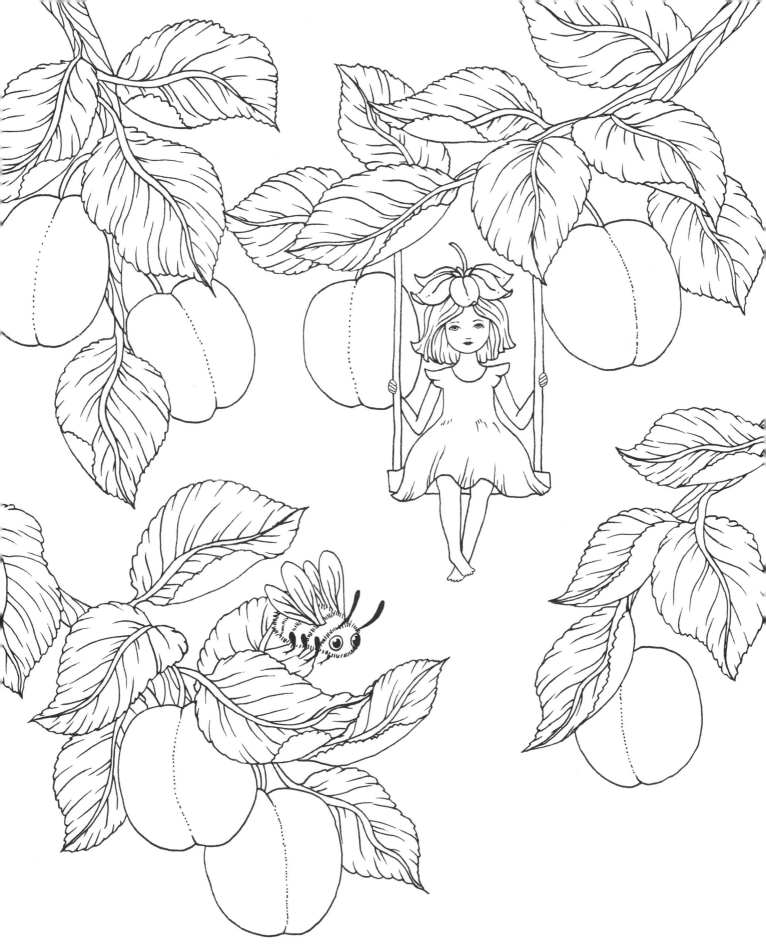

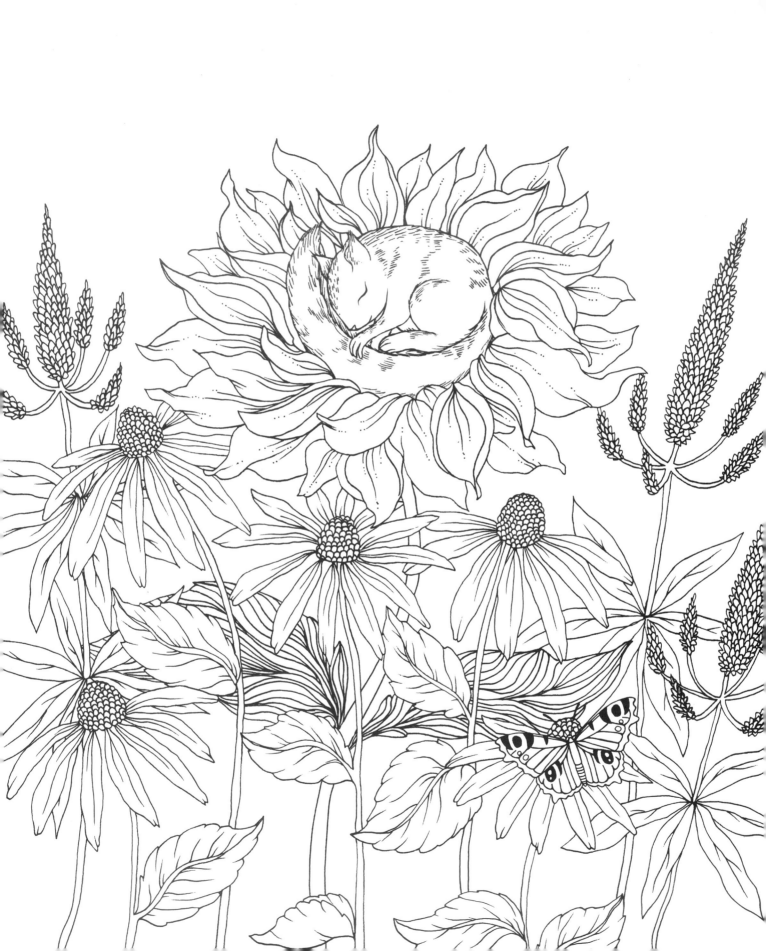

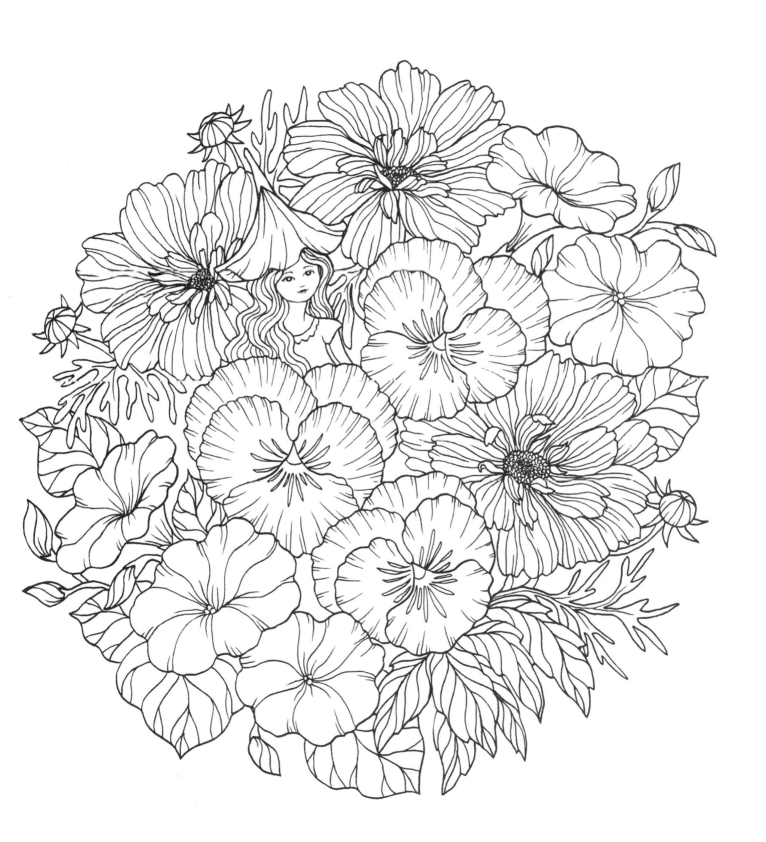

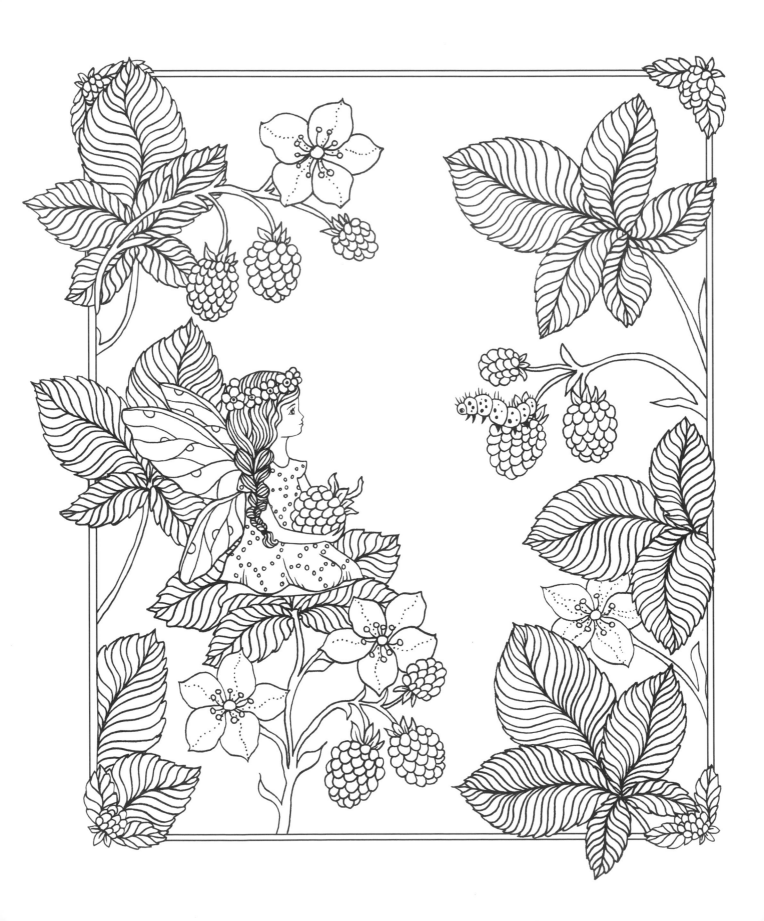

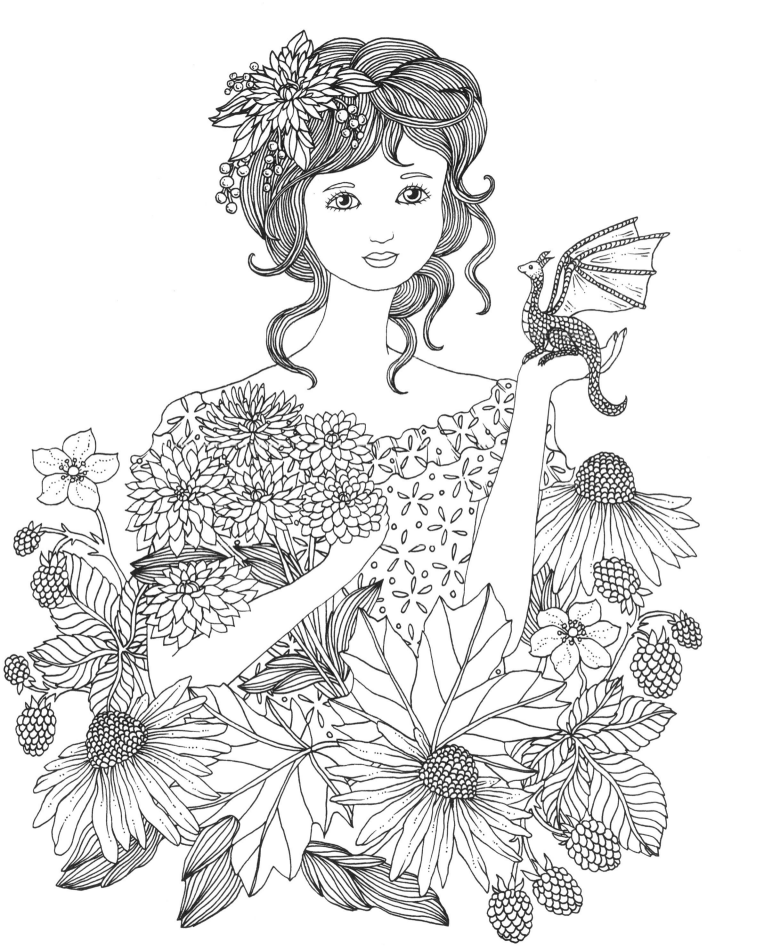

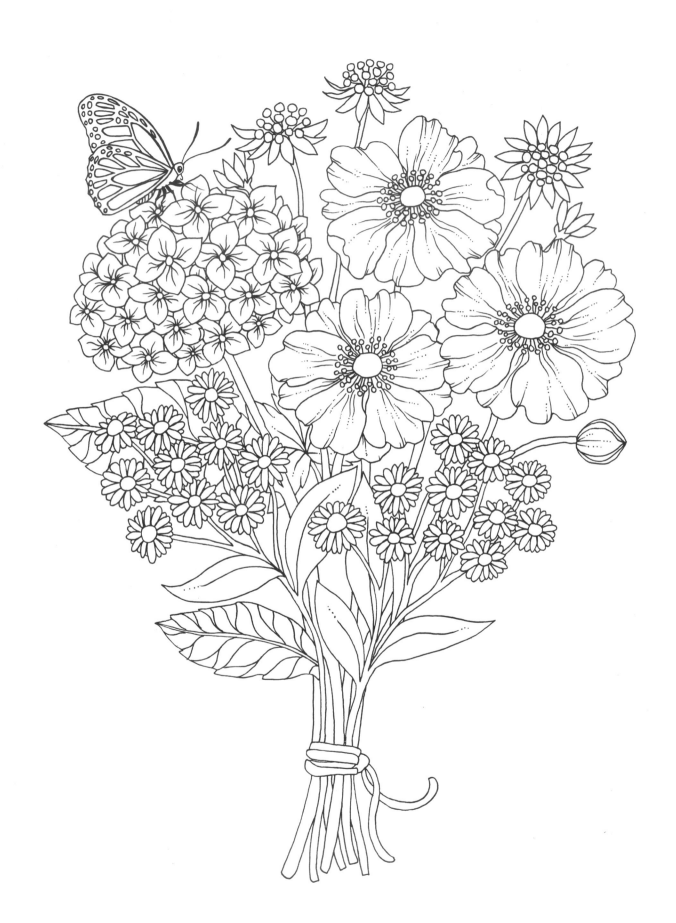

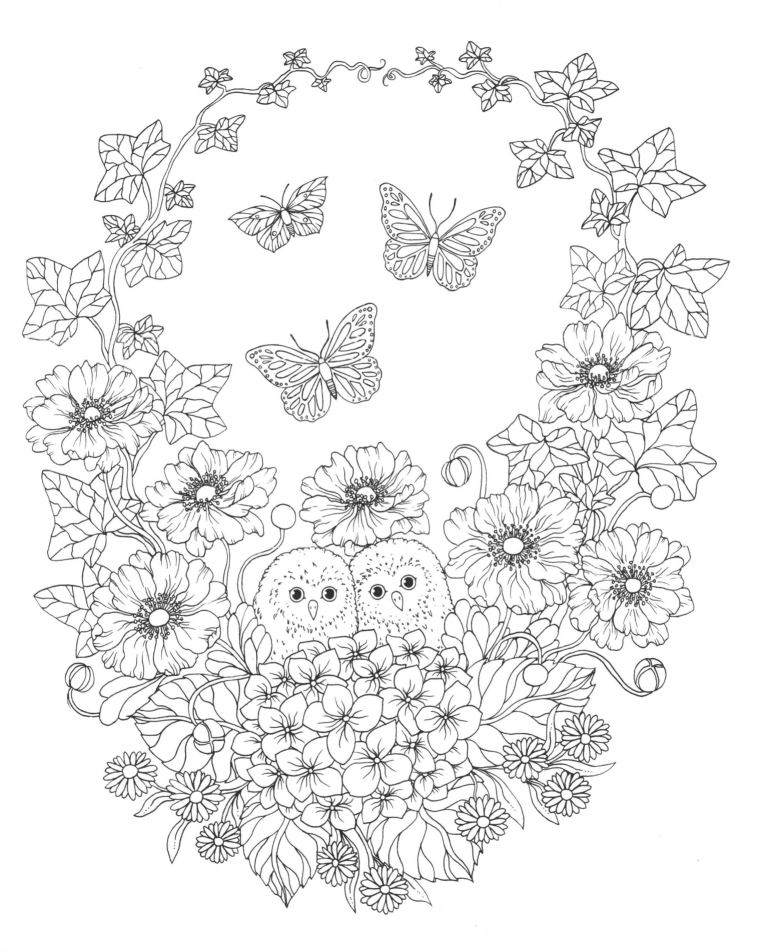

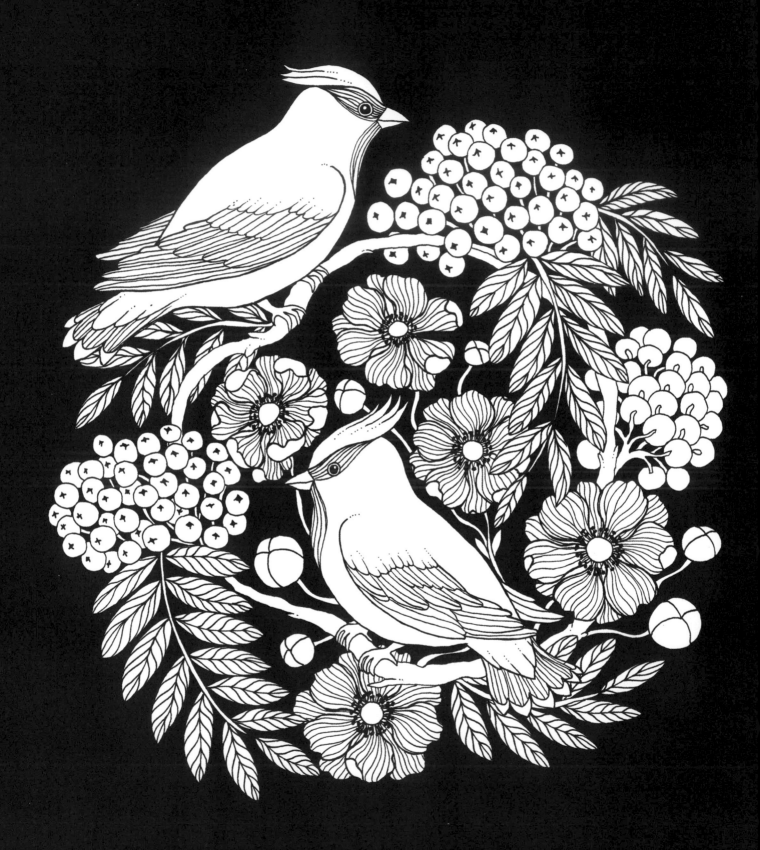

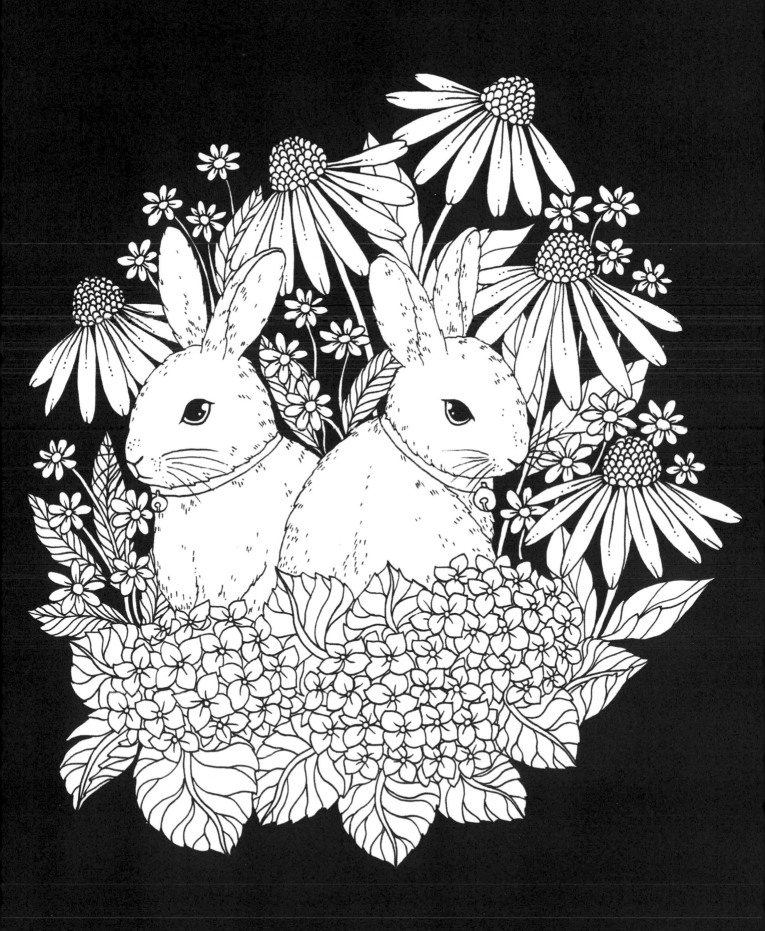

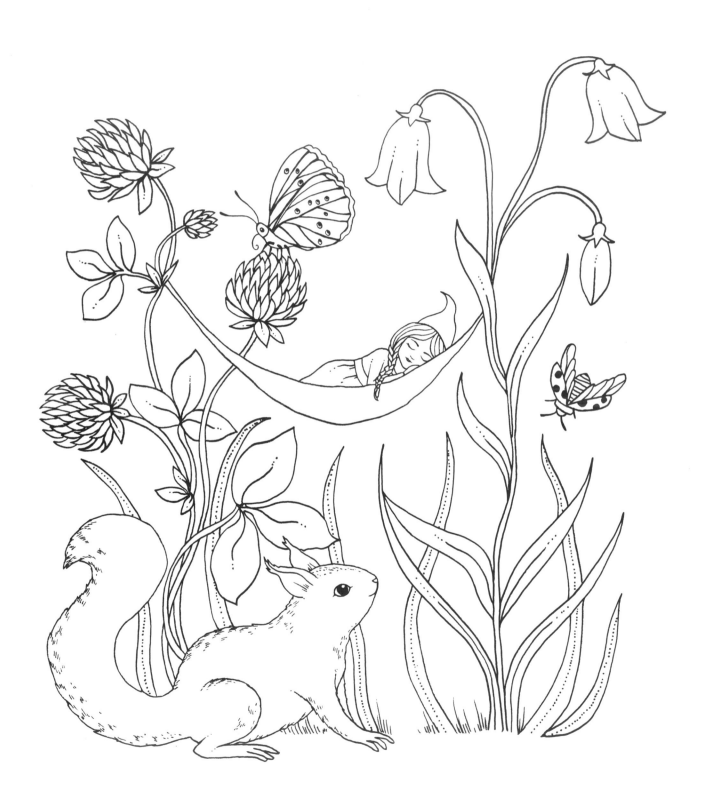

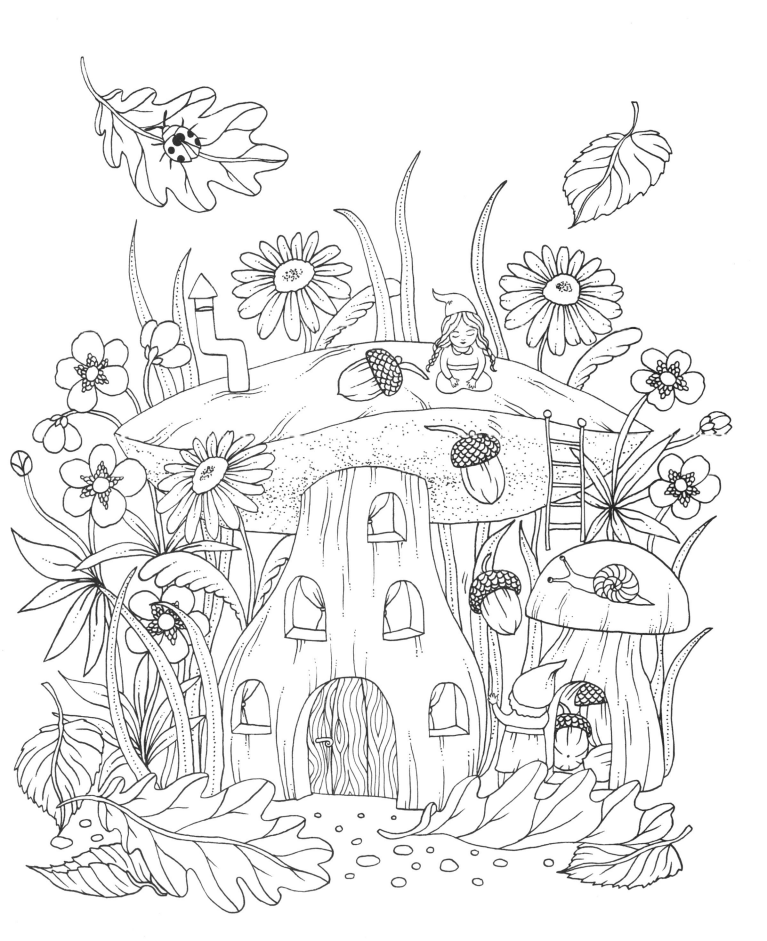

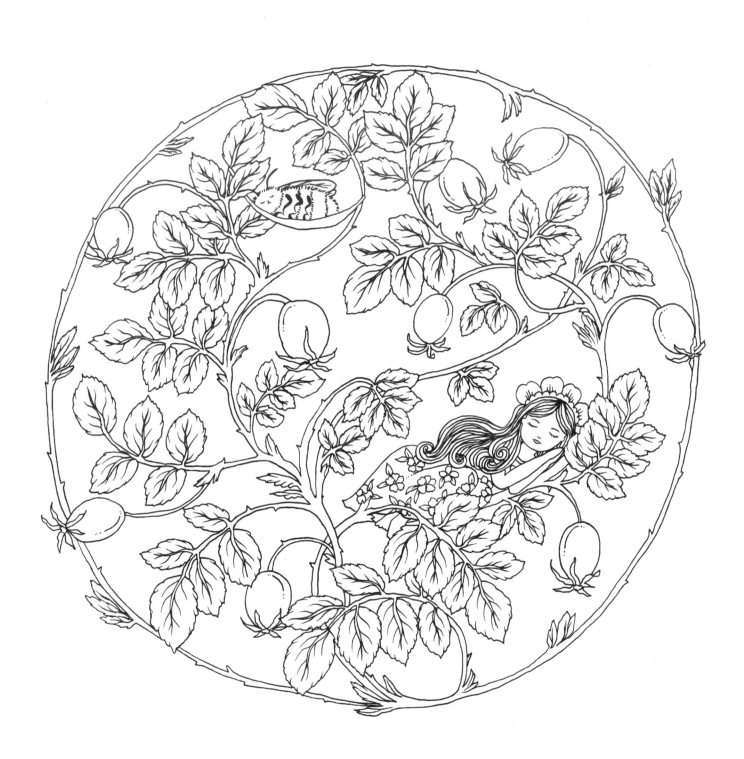

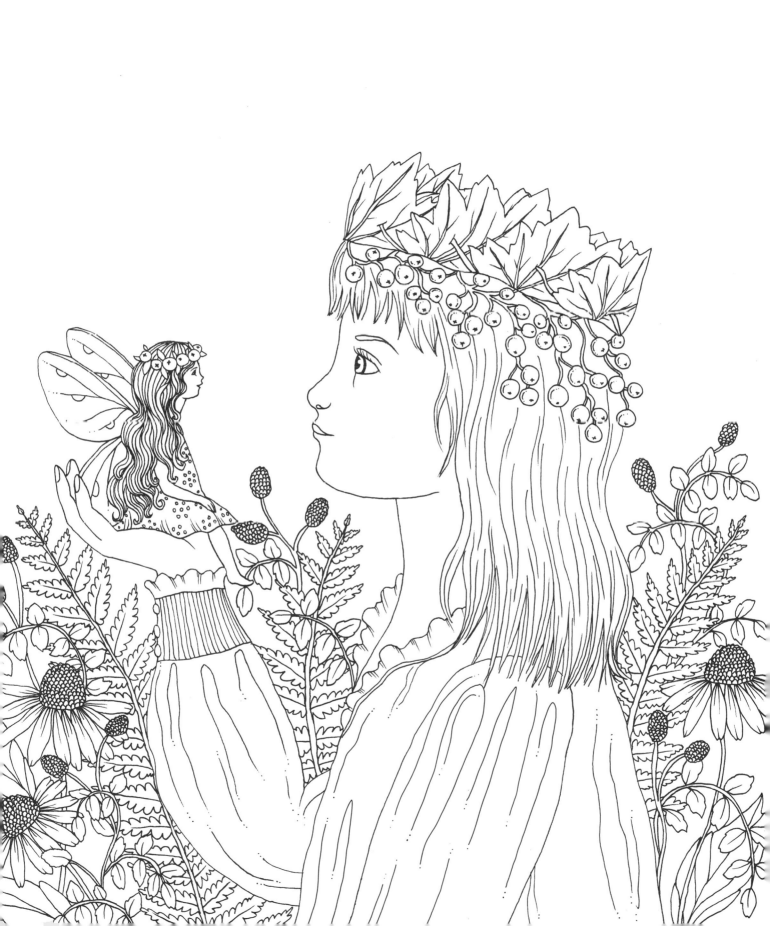

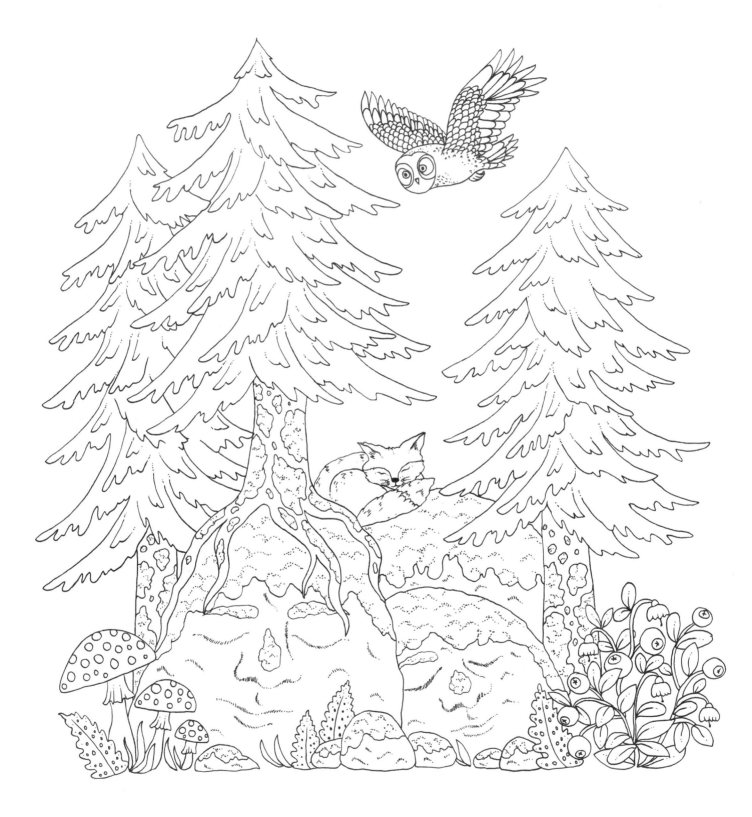

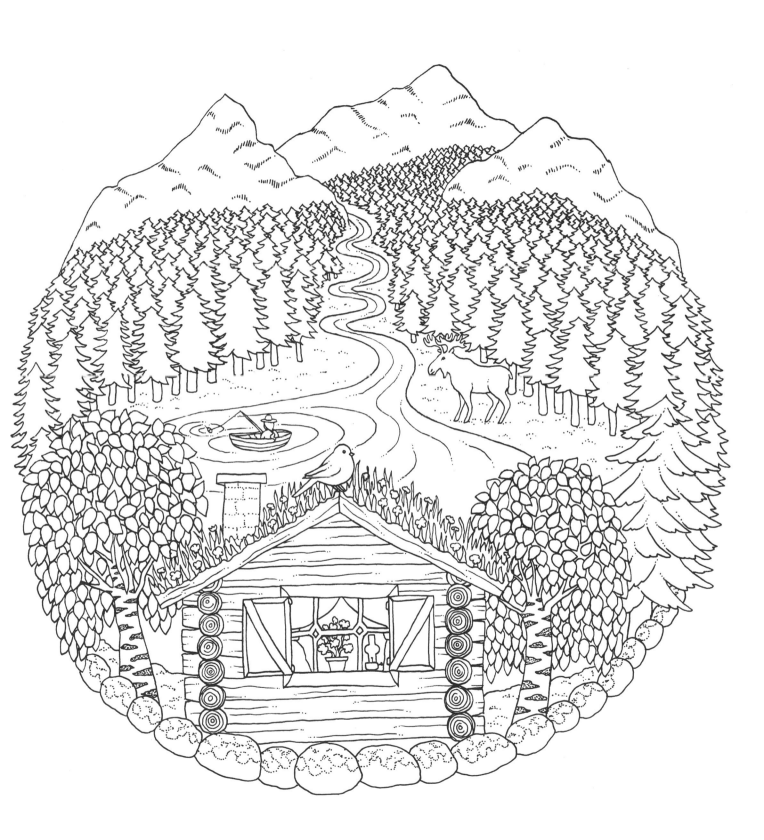

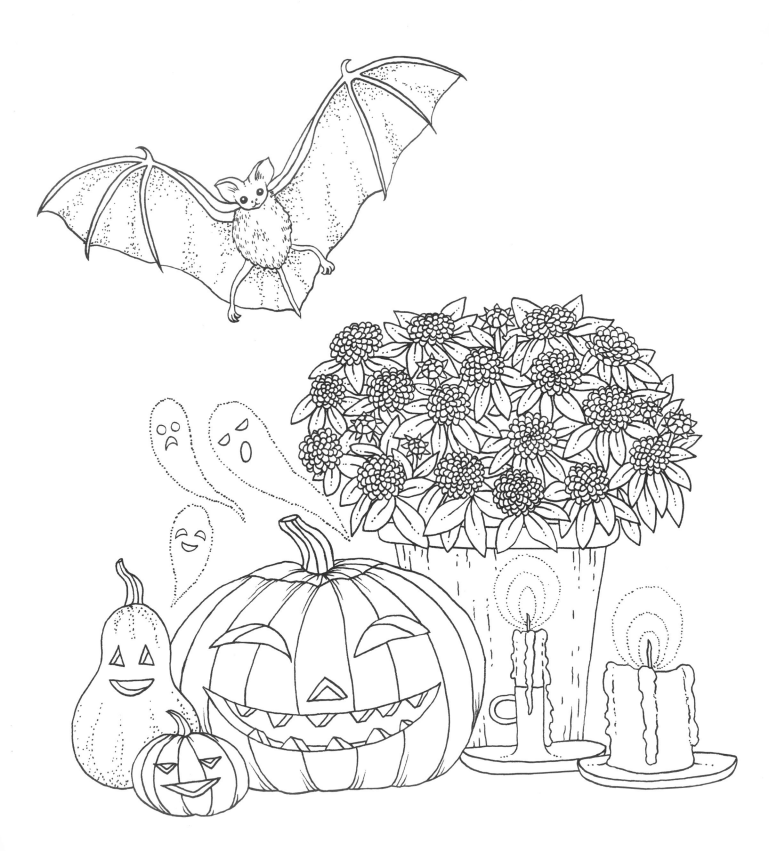

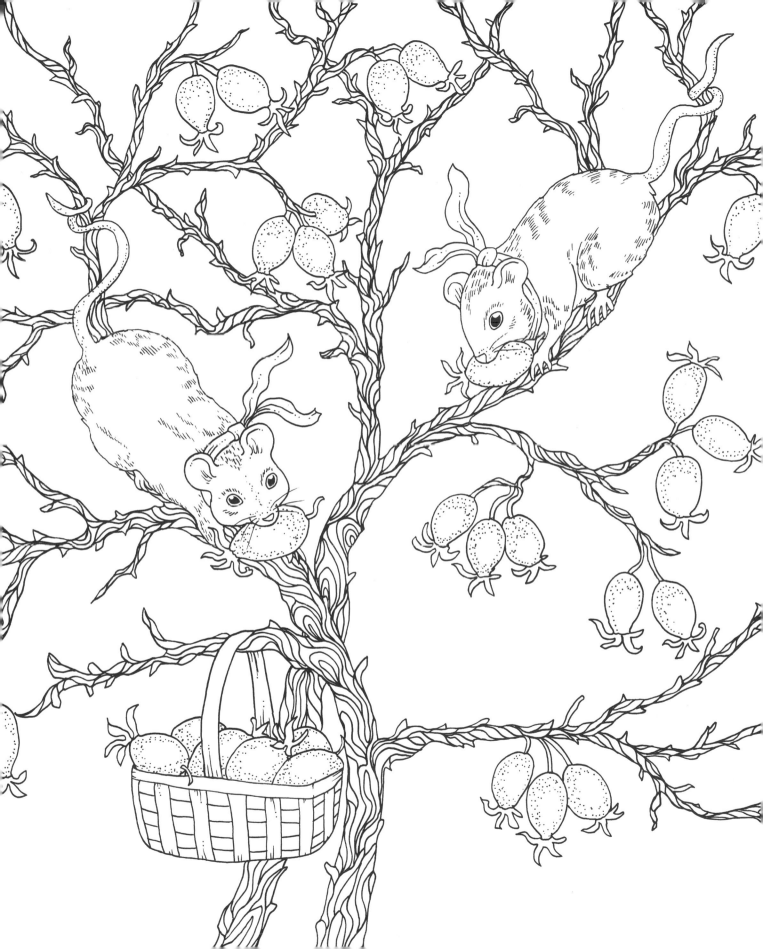

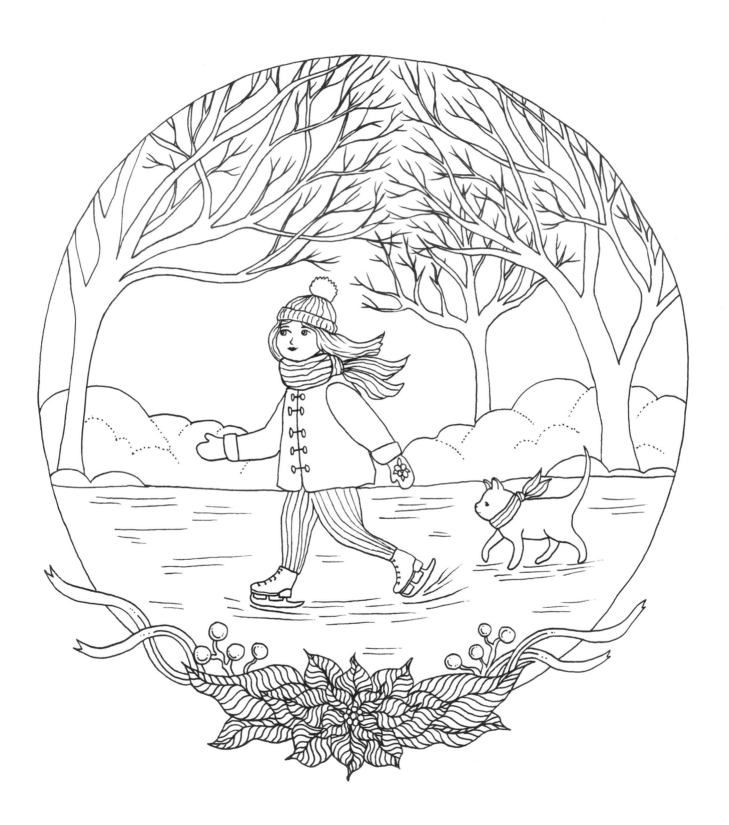

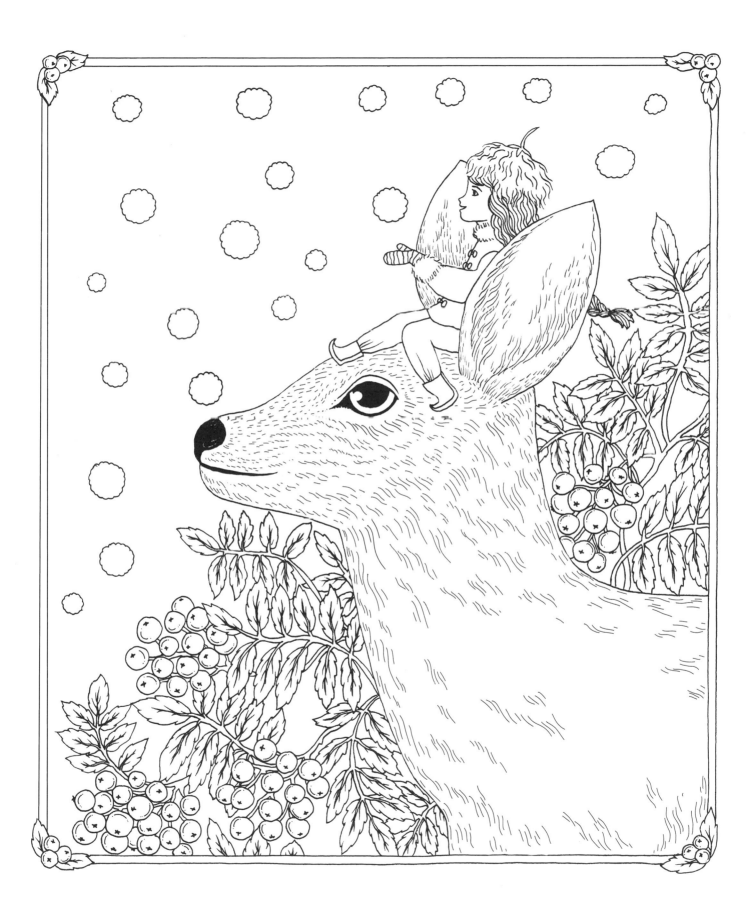

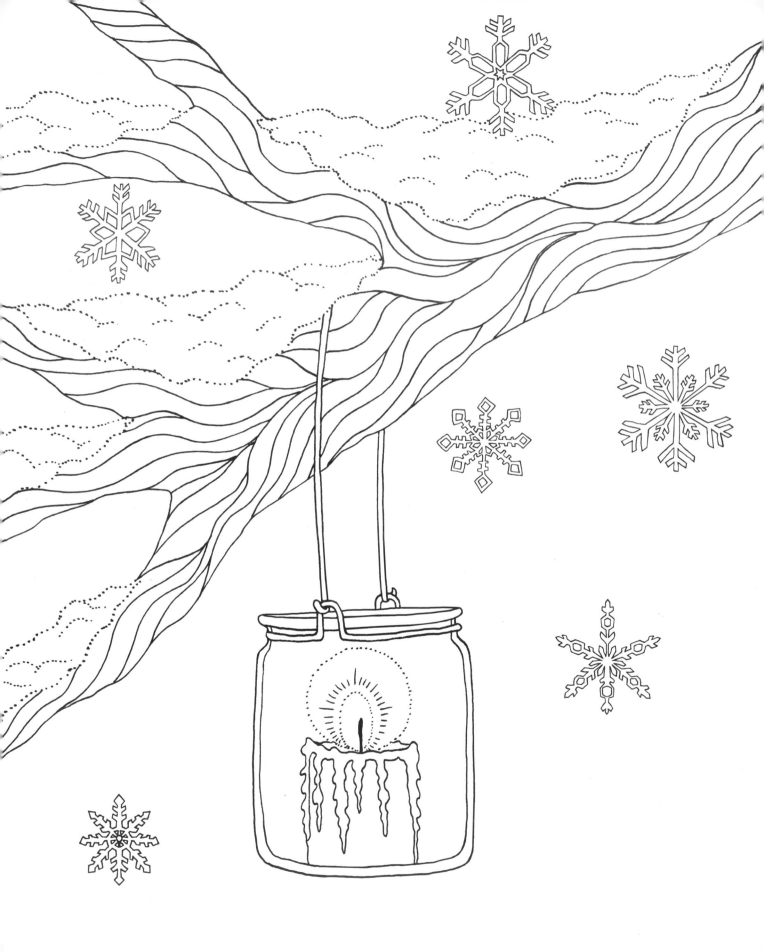

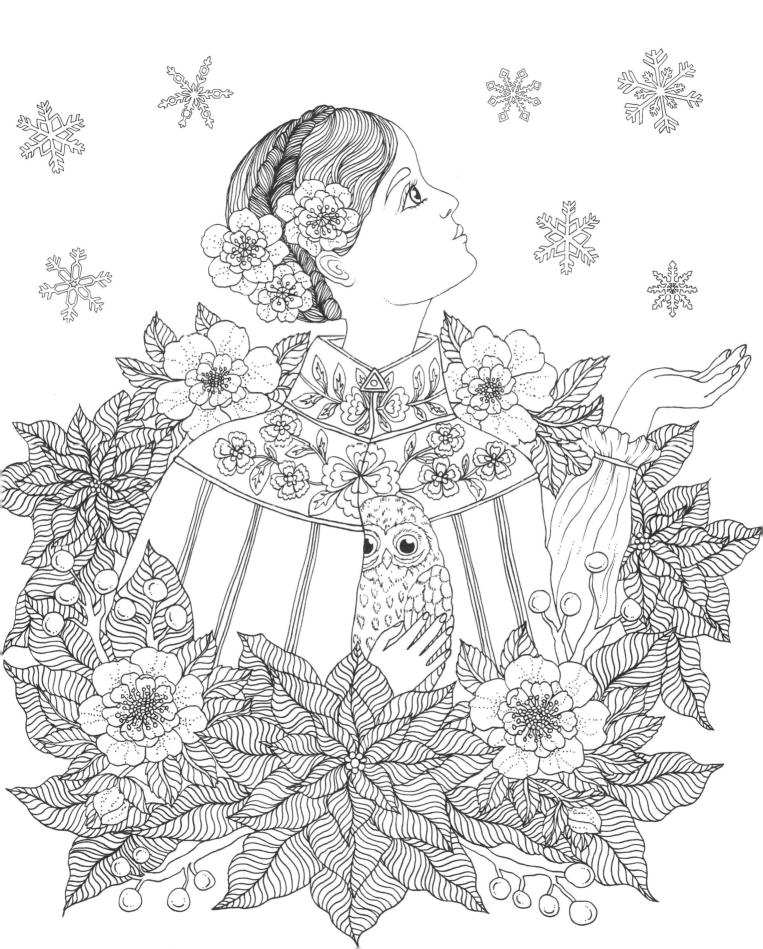

PLANT REGISTER

Plant names listed page by page; numbering begins with the title page as 1.

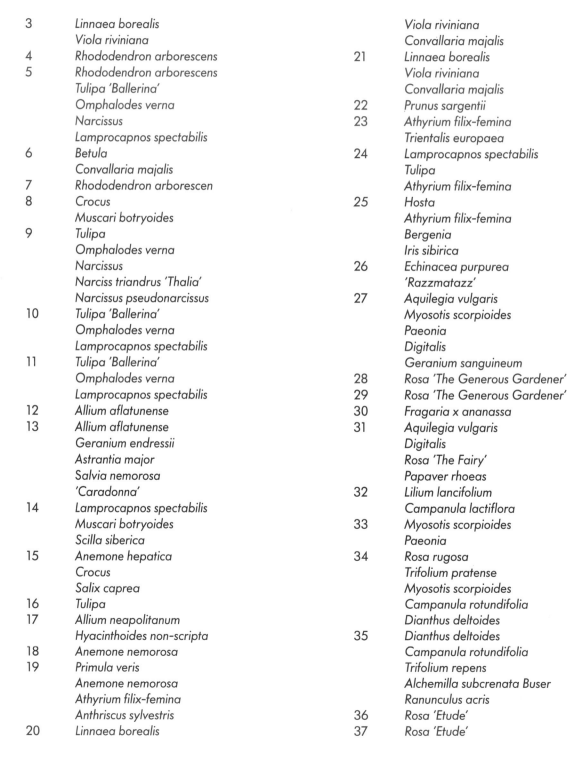

REGISTER

Insects Register

Other animals featured:

Bumble bee, squirrel, rabbit, deer, fawn, forest mice, hedgehog, frog, snail, dog, cat, mackerel, herring, harbor seal, green crab, barnacles, pigeon, red fox, bat, and moose.

TEST YOUR PENS HERE.